Simon Wilson

BEARDSLEY

PHAIDON

The author and publishers would like to thank all those museum authorities and private owners who have kindly allowed works in their possession to be reproduced. Plates 23, 27 and 37 are reproduced by kind permission of the Trustees of the Tate Gallery. Plate 19 is reproduced by kind permission of the Trustees of the British Museum.

*Phaidon Press Limited, Littlegate House, St Ebbe's Street, Oxford
Published in the United States of America by E. P. Dutton & Co., Inc.*

First published 1976

© *1976 Elsevier Publishing Projects SA, Lausanne/Smeets Illustrated Projects, Weert*

*ISBN 0 7148 1742 2
Library of Congress Catalog Card Number: 76–1533*

Printed in The Netherlands

BEARDSLEY

Aubrey Beardsley (1872–98) has given his name to a whole period of English cultural history. It was his friend, Max Beerbohm, who first referred to the 1890s as 'the Beardsley Period' and, because it expressed an essential historical truth, the name has stuck. We now see Aubrey Beardsley as the dominant artistic figure of his generation in England, and one whose work, unlike that of any of his contemporaries, had a great impact abroad. (The young Picasso, for example, was doing Beardsley pastiches in Barcelona in the mid-1890s.)

Beardsley worked almost exclusively in pen and ink, primarily as an illustrator and decorator of books – that is, he worked in a branch of the applied arts. But he was lucky to live in an era when, in England especially, the barriers between fine and applied art were down. An understanding of this historical situation is very important to a modern appreciation of the status of Beardsley's art, and it was well summarized by the critic, Gleeson White, who in 1893, just as Beardsley was beginning to become famous, concluded a long article on 'Artistic Book Covers' in *The Studio* with these words:

> 'Today is essentially a time when mean things are done so finely that future ages may refer to it as a period when the minor arts attracted the genius and energy now – from modesty or timidity – diverted from heroic enterprises. So as we collect the bric-à-brac of certain periods, and pay thousands for a piece of porcelain or some other article of the craftsman's production, it may be other ages will pass by our pictures and poems with a smile of contempt, and collect our book covers, our short stories, and a hundred ephemeral products, with keen interest. In place of the epic, a quatrain or a sonnet – instead of a fresco, a black and white sketch; no longer a cathedral, but a book cover; such, it seems, will be the verdict of the historian of the closing years of the nineteenth century.'

Such, indeed, is the verdict of the historian, for who can doubt that Beardsley's illustrated edition of *Le Morte d'Arthur* with its marvellous binding (reproduced in Gleeson White's article) (Plate 34) and his amazing drawings for Oscar Wilde's *Salomé* (Plates 12–21) are among the most interesting and memorable works of art produced in England in the 1890s.

The lasting fascination of Beardsley's art stems from a bizarre and unique combination of qualities: on the one hand great formal strength and stylistic originality, on the other the grotesque, the perverse, the macabre, the fantastic and the erotic – especially the erotic. The impact of this combination has never been better described, and the essence of Beardsley's art never better evoked, than by D. H. Lawrence when he introduced the *Salomé* drawings into his first novel, *The White Peacock*. (Thus, incidentally, fulfilling the theory of Baudelaire, whose *Les Fleurs du Mal* appears in *The Toilet of Salomé* [Plate 18], that the best account of a work of art can be another work of art.) Lawrence wrote:

> 'It happened, the next day after the funeral, I came upon reproductions of Aubrey Bearsdley's "Atlanta", and of the tail piece to "Salomé" and others. I sat and looked and my soul leaped out upon the new thing. I was bewildered, wondering, grudging, fascinated. I looked a long time, but my mind, or my soul, would

come to no state of coherence. I was fascinated and overcome, but yet full of stubbornness and resistance . . . I went straight to Emily, who was leaning back in her chair, and put the "Salomé" before her.

'Look' said I, 'look here!'

She looked; she was short-sighted, and peered close. I was impatient for her to speak. She turned slowly at last and looked at me, shrinking, with questioning.

'Well?' I said.

'Isn't it – fearful?' she replied softly.

'No – why is it?'

'It makes you feel – Why have you brought it?'

'I wanted you to see it.'

Already I felt relieved, seeing that she too was caught in the spell . . .

'Give it to me, will you?' George asked, putting out his hand for the book. I gave it him, and he sat down to look at the drawings . . .

'I want her more than anything – And the more I look at these naked lines, the more I want her. It's a sort of fine sharp feeling, like these curved lines. I don't know what I'm saying – but do you think she'd have me? Has she seen these pictures?'

'No.'

'If she did perhaps she'd want me – I mean she'd feel it clear and sharp coming through her.'

'I'll show her and see.'

The significance of this passage is that Lawrence was not only sensitive, as one would expect, to the eroticism of Beardsley, but also perceived the novelty of his style, and, most important of all, he understood the formal function of his art, the way in which expression is inherent in the very lines and structures of the drawings. He saw that Beardsley's art is in its way a very abstract art, and it is this which is the source of its underlying power.

Aubrey Vincent Beardsley was born in Brighton in 1872. As a child he was a gifted and precocious draughtsman, writer and musician, and a voracious reader. He was educated at Brighton Grammar School and went to London to earn a living at the age of sixteen. (His father had lost his money at about the time of Aubrey's birth, and his mother supported her children by working as a governess and piano teacher.) Beardsley became a clerk, a job he hated, first at the District Surveyor's office in Clerkenwell, then at the Guardian Life and Fire Insurance office in the City. There he met a bookseller, Frederick Evans, who was the first to recognize the quality of Beardsley's drawings, some of which he took in exchange for books.

At this stage Beardsley received important encouragement in his career as an artist from Edward Burne-Jones, then in his last years, and one of the grand old men of British art. Burne-Jones was the strongest single stylistic influence on Beardsley's early work, and in July 1891 Beardsley called on him at his studio in London and managed, before he left, to show the great man some of his drawings. The next day he wrote to his old schoolmaster, R. W. King, recording Burne-Jones's reaction: 'Nature has given you every gift which is necessary to become a great artist. I *seldom* or *never* advise anyone to take up art as a profession, but in *your* case I *can do nothing else.*' As a result of this meeting Beardsley joined the Westminster School of Art, where for a year he attended evening classes, the only formal training he ever received.

During 1892 Beardsley added to the influence of Burne-Jones that of Japanese art and, by the end of that year, had evolved a style that he called 'Japanesque', but which was entirely his own. *Le Dèbris* [sic] *d'un Poète* (The Remains of a Poet) (Plate 2), probably drawn in the summer of 1892, is his first masterpiece in this manner, and marks his maturity as an artist. At this time Beardsley was just twenty. He was also dying of tuberculosis. His first serious haemorrhage of the lung had occurred in 1889, and had prevented him drawing for some time. He was ill again in the first months of 1892, and these incapacitating bouts were to continue at intervals until his death in March 1898.

In June 1892 Beardsley went to Paris, where his drawings were seen and appreciated by none other than Puvis de Chavannes, then President of the Salon des Beaux Arts, who referred to him as 'un jeune artiste anglais qui fait des choses étonnantes' (a young English artist who does astonishing things). On his return to London Beardsley was commissioned by J. M. Dent to illustrate *Le Morte d'Arthur*, Sir Thomas Malory's fifteenth-century English version of the Arthurian legend. This huge commission (for 20 full page drawings, 100 small drawings, 350 initial letters and a cover design) marks the beginning of Beardsley's professional career and, with other smaller jobs that came in from other publishers, it enabled him, in October 1892, to give up his job as a clerk. In April 1893, a new art magazine, *The Studio*, appeared in London. The first issue had a cover designed by Beardsley, and also contained a long, copiously illustrated article on him by Joseph Pennell. This article brought Beardsley to the attention of a wide public, and marks the beginning of his fame. In June the first part of *Le Morte d'Arthur* appeared (Dent had decided to publish in monthly parts), and Beardsley also undertook the second great commission of his career, this time from John Lane, for illustrations to Oscar Wilde's play *Salomé*. This was published in March 1894, and Beardsley's drawings created a tremendous stir, the more so since the play itself was the subject of scandal, having been banned by the Lord Chamberlain when Wilde attempted to stage it in June 1892. *The Times*, for example, described them as 'fantastic, grotesque, unintelligible for the most part and, so far as they are intelligible, repulsive'.

While engaged on illustrating *Salomé* Beardsley met an expatriate American writer called Henry Harland. The two became friends and, lunching together on New Year's Day 1894, they conceived the idea of starting a magazine. Harland was to be the literary editor, and Beardsley the art editor. Their aim, as Harland later recorded, was to publish freely their own work: 'And then and there we decided to have a magazine of our own. As the sole editorial staff we would feel free and welcome to publish any and all of ourselves that nobody else could be lured to print.' This magazine came into being as *The Yellow Book* and was published by John Lane. The first issue appeared in April 1894, and renewed the sensation created by *Salomé*. Particular objection was taken to two of Beardsley's drawings; *L'Education Sentimentale* (Plate 26) and the portrait of *Mrs Patrick Campbell* (Plate 24). The *Westminster Gazette* summed up the feeling of the establishment in its comment, 'As regards certain of his [Beardsley's] inventions in this number, especially the thing called 'The Sentimental Education' and that other thing to which the name of Mrs Patrick Campbell has somehow become attached, we do not know that anything would meet the case except a short Act of Parliament to make this kind of thing illegal.'

Four volumes of *The Yellow Book* appeared under Beardsley's art editorship between

April 1894 and April 1895. Publication of *Le Morte d'Arthur* was completed in the summer of 1894. Beardsley was also designing a series of modern novels, the 'Keynotes', for Lane and undertaking other commissions for books and posters. During this year he was, although he didn't know it, at the peak of his short but glittering career.

On Friday 5 April 1895, the art and literary world of London was shaken to its foundations by the arrest of Oscar Wilde on charges of homosexuality. Although Wilde and Beardsley were far from being friends they were associated in the public mind, mainly because of *Salomé*. Also, it was widely reported (almost certainly incorrectly) that Wilde, when arrested at the Cadogan Hotel, tucked a copy of *The Yellow Book* under his arm before accompanying the police to Bow Street. As John Lane later said, 'It killed *The Yellow Book* and it nearly killed me'. Lane was in the U.S.A. at the time of Wilde's arrest, but he soon began to receive cables from his more respectable authors (led by Mrs Humphry Ward) demanding Beardsley's dismissal. One of these was from the poet, William Watson: 'WITHDRAW ALL BEARDSLEY'S DESIGNS OR I WITHDRAW ALL MY BOOKS'. This seems to have been the last straw for Lane. He sacked Beardsley and withdrew all his work from Volume 5 of *The Yellow Book*, which was then going through the press.

Beardsley quickly found another publisher, the much maligned Leonard Smithers, a remarkable man who, as Maurice Girodias, John Calder and the Grove Press have done since, published erotic and avant-garde literature side by side, the one financing the other. From this time on Beardsley ceased to operate in the respectable public domain, and became part of the *demi-monde* that he so delighted in depicting. Smithers initially approached Beardsley (whom he already knew as a customer at his bookshop in Arundel Street) to become art editor of a periodical called *The Savoy*, planned to take over the territory abandoned by *The Yellow Book* after the arrest of Wilde. The first issue of *The Savoy*, with a cover by Beardsley, came out in January 1896, and was a much more genuinely advanced, and much more interesting publication, than *The Yellow Book* had ever been. Literary contributors included Paul Verlaine, Havelock Ellis (writing on Zola), Bernard Shaw, W. B. Yeats and last, but not least, Beardsley himself. His erotic tale *Under the Hill* was published (in expurgated form) with illustrations by the author (Plate 35) in the first two issues of *The Savoy*. This story, based on the legend of Venus and Tannhauser, was left unfinished at his death, but what there is of it remains a quintessentially *fin de siècle* piece of writing, and has ensured Beardsley the niche in literary history that he coveted. It was published in full by Smithers in 1907 and has since been reprinted several times.

Early in 1896 Beardsley's health suffered a breakdown which marked the beginning of the end for him. But he continued to work throughout the year at a feverish pace and, during a stay at the Spread Eagle Hotel at Epsom in July 1896, he produced his last great masterpieces of book illustration, the drawings for Aristophanes' sexual comedy *Lysistrata* (Plates 43, 44, 48, 49). As has happened with *Under the Hill*, the overt sexuality, and especially the extreme phallicism of the *Lysistrata* drawings, has blinded many critics to their quality: they are among Beardsley's very finest works. The phallicism, incidentally, is entirely due to Beardsley faithfully following the text. As he wrote to Smithers when sending him a proof of one of the drawings, 'If there are no cunts in the picture, Aristophanes is to blame and not your humble servant.'

In the last year of his life Beardsley was almost continuously ill and, after his

reception into the Roman Catholic Church in March 1897, he spent most of the rest of the year in Paris and Dieppe in search of health, before finally moving to Mentone in the south of France in November. There he died on the morning of 16 March 1898. He was still only twenty-five years old.

The Plates

Plate 1. *Merlin.* About 1893–4. Illustration for *Le Morte d'Arthur.* Pen and ink, diameter 15 cm. Washington, Library of Congress, Rosenwald Collection.

Beardsley's practice of depicting the familiar characters of the Arthurian legend as bizarre and sinister creatures is particularly appropriate in the case of Merlin the magician.

Plate 2. *Le Dèbris* [sic] *d'un Poète* (The Remains of a Poet). 1892. Pen, Indian ink and wash, 33 × 12·5 cm. London, Victoria and Albert Museum.

A wry self-portrait recording Beardsley's situation in 1892, when he was still working at his hated job as a clerk at the Guardian Insurance office in London. It is an image of the sensitive young poet crushed by enforced contact with the material world. It is significant that Beardsley refers to himself as a poet; he attached great importance to literature, and there is evidence that he thought of himself all his life as a literary man, rather than as an artist. Also, the idea that art and poetry are closely related was an important and influential one in the late nineteenth century.

Stylistically, this drawing marks Beardsley's development, towards the end of 1892, of a manner which, while it blended a number of influences, Burne-Jones, Whistler and Japanese prints most important among them, was, to use the artist's own words, 'fresh and original'. In particular this is one of the first drawings to reveal fully Beardsley's extraordinary ability to create powerful abstract patterns of line, form and space, which are also vivid figurative images packed with meaning.

Drawing a self-portrait from a rear view is entirely characteristic of Beardsley's perverse wit and the delight he took in breaking the accepted rules and conventions of art.

Plate 3. *How King Arthur Saw the Questing Beast.* 1893. Drawing for the frontispiece of vol. I of *Le Morte d'Arthur.* Pen, ink and wash, 35·5 × 17 cm. London, Victoria and Albert Museum.

Signed and dated 'March 8 1893' on the bases of the tree trunks in the left foreground, this drawing is in one of Beardsley's early styles, the 'hairy line'. Here Beardsley entirely covers the paper in a fantastic proliferation of detail, which repays careful scrutiny: not many people, for instance, spot the phallus quite clearly depicted among the decorative detail of the lake bank at the left edge of the drawing. The ithyphallic faun in the background is more noticeable.

Beardsley's King Arthur is remote from the conventional image of him in art and literature. An emaciated, elaborately coiffed young dandy, he looks hardly capable of rising from his semi-recumbent posture, let alone grasping his sword. Beardsley hints at the source of this lassitude in the dark circles under Arthur's eyes. Many of Beardsley's figures, both male and female, have this look and it is something he undoubtedly took, and exaggerated, from the art of Edward Burne-Jones. Its significance was brilliantly summarized by the French critic Octave Mirbeau, when he wrote, 'Those bruised eyes are unique in art, one cannot tell whether they are the result of onanism, sapphism, natural love or tuberculosis!'

Plate 4. *How Queen Guenever Made Her a Nun.* About 1893–4. Illustration to *Le Morte d'Arthur.* From the line block.

One of the earliest drawings in which Beardsley uses overwhelming quantities of black to create mysterious and sinister effects. His Guenever, like his King Arthur (Plate 3), is remote from convention; her hood forms the outline of a raven's beak, a bird associated with witchcraft, and Beardsley shows enough of her face for us to see that it is most un-nunlike, with bruised eyes, sensual mouth and depraved expression. The drawing is,

8

like many of Beardsley's works, a calculated blasphemy whose spirit is echoed in the writing vegetation of the border, a fine example of Beardsley's decorative talent.

Plate 5. *How La Beale Isoude Nursed Sir Tristram.* About 1893–4. Illustration to *Le Morte d'Arthur.* Pen and ink, 28 × 22 cm. Harvard University, Fogg Art Museum, Scofield Thayer Collection.

One of Beardsley's most refined and masterly drawings for *Le Morte d'Arthur.* Here his means are rigorously restrained, even in the lush borders, yet the total effect is still richly decorative. La Beale Isoude's hair is a particularly notable example of Beardsley's ability to work on the very borderline between abstraction and representation. The elaborate and fantastic candlestick was a favourite device of Beardsley's, and appears in many of his drawings from this time on.

Plate 6. Heading of Chapter XXXIII in *Le Morte d'Arthur.* About 1893–4. From the line block.

The extraordinary formalization of the hair of the two girls occurs also in the drawing, *How La Beale Isoude Nursed Sir Tristram* (Plate 5), but here it takes over the whole drawing to create a vigorous abstract pattern.

Plate 7. Heading of Chapter XIV in *Le Morte d'Arthur.* About 1893–4. From the line block.

One of the many bizarre creatures which appear in the small chapter headings throughout *Le Morte d'Arthur,* and which, as much as the full page illustrations, give the book its sinister atmosphere.

Plate 8. *Woman in Café* or *Waiting.* About 1893–4. Pen and ink, 19·4 × 9·2 cm. London, Brian Reade.

This drawing was published as a decoration in *Bon-Mots of Foot and Hook,* but stylistically it is one of the earliest drawings in Beardsley's 'Yellow Book' manner of 1894–5. It is one of a number of drawings of sinister *demi-mondaines* done by Beardsley during the period. (See also notes to Plates 22, 23.)

Plate 9. Vignette for p.26 in *Bon-Mots of Smith and Sheridan.* 1893. Pen and ink, 5.4 × 9·9 cm. London, Victoria and Albert Museum.

The most striking of the sinister little drawings Beardsley did for the volumes of *Bon-Mots* published by J. M. Dent from 1893. On the title page of the books they are referred to as 'grotesques', and Beardsley once wrote, 'I have one aim – the grotesque. If I am not grotesque I am nothing.'

Plate 10. *How Sir Tristram Drank of the Love Drink.* About 1893–4. Illustration for *Le Morte d'Arthur.* Pen and ink, 28 × 20 cm. Harvard University, Fogg Art Museum, Scofield Thayer Collection.

Sir Tristram and La Beale Isoude are on board a ship, although the only indications of this given by Beardsley are the stylized waves and seagulls just visible in the gap between the screens. They have found a love potion intended for someone else and unknowingly drink it. The birth of their passion is symbolized by the huge exotic flowers blooming above their heads, and by the frieze of roses, more conventional symbols of love, behind them.

Plate 11. *Of a Neophyte and How the Black Art was Revealed unto Him by the Fiend Asomuel.* 1893. Illustration to 'The Black Art, Part II' by James Mew in *The Pall Mall Magazine,* vol. I, June 1893. From the line block.

Beardsley's most splendidly satanic drawing, full of richly sinister decoration, and with the inexpressibly evil face of the fiend Asomuel at the centre of the composition. It is

possible that the neophyte represents the artist himself, that the 'Black Art' is a punning reference to Beardsley's own art, and that he is jokingly implying that he was taught it by a devil from hell.

Plate 12. *J'ai Baisé ta Bouche, Iokanaan* (I have Kissed thy Mouth, Iokanaan). Early 1893. Pen, ink and green watercolour wash, 28 × 15 cm. Princeton University Library, Gallatin Beardsley Collection.

This drawing represents Salome with the head of John the Baptist and is in illustration not to the Bible but to Oscar Wilde's version of the story. Wilde's play, *Salomé*, was first published early in 1893 in Paris in French, the language Wilde wrote it in. Beardsley read the book when it first appeared and made this drawing almost immediately. He has chosen the climactic moment of the play, when Salome grasps the head of John and kisses it full on the lips. Wilde's introduction of an overtly necrophiliac theme into the Bible story must have appealed to Beardsley's love of the perverse. Wilde, in fact, makes Salome's motivation an entirely sexual one – the Baptist rejects her advances, and she contrives his death simply so that she may satisfy her lust for him without resistance. *J'ai Baisé ta Bouche* was one of the drawings by Beardsley reproduced in the first issue of *The Studio* in April 1893, and led to the commission from John Lane to illustrate the English edition of *Salomé*.

Plate 13. *The Woman in the Moon.* 1894. Illustration to *Salomé* by Oscar Wilde. Indian ink over pencil, 22·2 × 16·5 cm. Harvard University, Fogg Art Museum, Grenville L. Winthrop Bequest.

This drawing was used as the frontispiece for *Salomé* and provides a suitably startling overture to what follows. In it, Beardsley has brought to an absolute pitch of assurance and perfection the style of dramatic abstraction he had been developing over the year previous to its execution.

The face in the moon is not, in fact, that of a woman, but a caricature of Oscar Wilde, and the title of the drawing is presumably a satirical reference to Wilde's homosexuality. Beardsley caricatured Wilde in a number of the illustrations to *Salomé*, and future relations between the two were far from cordial.

Plate 14. *The Eyes of Herod.* 1894. Illustration to *Salomé* by Oscar Wilde. Indian ink over pencil, 22·2 × 17·5 cm. Harvard University, Fogg Art Museum, Grenville L. Winthrop Bequest.

This is the most gorgeous and richly decorative of the *Salomé* illustrations, full of daring dramatic effects, such as the reduction of the lower part of the figure of Salome to three curving lines, and the elimination of all but the head of Herod (a caricature of Wilde). Also masterly is the flame-like line dancing above the candle flames proper, and the massing of dense blacks at either edge of the drawing.

The peacock motif, used for the cover design of *Salomé* and in other illustrations, is derived from Whistler's famous Peacock Room, which Beardsley visited in 1891.

Plate 15. *The Stomach Dance.* 1894. Illustration to *Salomé* by Oscar Wilde. Indian ink over pencil, 22·2 × 17·5 cm. Harvard University, Fogg Art Museum, Grenville L. Winthrop Bequest.

A number of the *Salomé* illustrations were censored by John Lane, the publisher of *Salomé*, but the novelty of Beardsley's style fortunately defeated him in a number of instances. Here he failed to notice the bulging phallus of Salome's accompanist, presumably a tribute to the dancer's erotic impact.

Plate 16. *Enter Herodias.* 1894. Illustration to *Salomé* by Oscar Wilde. 17·8 × 12·9 cm. From the line block. Princeton University Library, Gallatin Beardsley Collection.

Another of the *Salomé* illustrations that were censored by John Lane, who in this case objected to the nudity of the page boy and demanded a fig leaf. Beardsley altered the

drawing under protest and sent a proof, here reproduced, of the original, to a friend inscribed with these words:

> 'Because one figure was undressed
> This little drawing was suppressed
> It was unkind
> But never mind
> Perhaps it all was for the best.'

As in some other cases (e.g. *The Stomach Dance* [Plate 15]), Lane's censorship of this drawing was incomplete. The two candlesticks are very obviously phallic, and the clothes of the grotesque attendant on the left clearly form the outline of an enormous erection, the tip of which Beardsley has jokingly placed against the candle flame. The satanic master of ceremonies on the right, carrying a copy of the play, is a caricature of Wilde.

Plate 17. *Enter Herodias.* 1893. Illustration to *Salomé* by Oscar Wilde. Published version. Pen and ink on paper, 21·6 × 15·4 cm. Los Angeles, County Museum of Art.

See note to Plate 16. Here Beardsley has added to the page-boy a fig leaf so eye-catching, with its incongruous neat little bow, that it draws attention both to Lane's ridiculous act of censorship and to the censored parts themselves. This very important drawing has only recently been rediscovered, after having been lost for half a century.

Plate 18. *The Toilet of Salome.* First version. 1894. Illustration to *Salomé* by Oscar Wilde. Indian ink over pencil, 22·9 × 16·2 cm. From the line block.

This drawing was suppressed by John Lane, the publisher of *Salomé*, on the grounds of indecency. The main objection, apparently, was the pubic hair and just perceptible tumescence of the boy on the Japanese stool, but Beardsley introduced a number of other provocative features: the nudity of Salome and the position of her left hand, the pierrot's skirts which form an enlarged outline of Salome's breasts, the nudity of the page boy, the ambiguous gesture of the muscian's hand on the long stem of his instrument, the foetus on the dressing table and the row of books, which include Baudelaire's *Les Fleurs du Mal* and Zola's *La Terre*, which at that time was considered pornographic.

Plate 19. *The Toilet of Salome.* Second version. 1894. Illustration to *Salomé* by Oscar Wilde. Indian ink over pencil, 20·9 × 16·1 cm. London, British Museum.

This is the illustration Beardsley produced to replace the suppressed *Toilet of Salomé* (Plate 18). He has eliminated both the indecencies and the profusion of detail of the previous drawing, and there is no doubt that the result is formally much more satisfying. In a letter to Robert Ross about the *Salomé* drawings, Beardsley wrote, 'I have withdrawn three of the illustrations and supplied their places with three new ones (simply beautiful and quite irrelevant)'. He did manage a small gesture of defiance by including among the books on the dressing table a volume by the Marquis de Sade.

Plate 20. *The Climax.* 1894. Illustration to *Salomé* by Oscar Wilde. From the line block.

This is the tidied-up and much more forceful version of *J'ai Baisé ta Bouche, Iokanaan* (Plate 12), which Beardsley did for the 1894 edition of *Salomé*.

Plate 21. *The Dancer's Reward.* 1894. Illustration to *Salomé* by Oscar Wilde. Indian ink over pencil, 22·2 × 15·9 cm. Harvard University, Fogg Art Museum, Grenville L. Winthrop Bequest.

Beardsley rose splendidly to the task of creating a fresh iconography for a subject, Salome receiving the head of John the Baptist, not uncommon in the history of art. The idea of the executioner's arm shooting up from the bottom of the drawing is totally original and intensely dramatic. Furthermore, the arm with its platter has been turned by Beardsley into a kind of baroque occasional table, over which bends the delighted Salome. Beardsley hints at vampirism in the gesture of Salome's left hand; she is dipping a finger in the blood, astonishingly treated by Beardsley as a decorative element, as if to taste it.

Plate 22. Design for the front cover of the prospectus for *The Yellow Book*, vol. I. April 1894. Indian ink, 24·1 × 15·6 cm. London, Victoria and Albert Museum.

After the *Salomé* drawings Beardsley's style changed somewhat, a change which corresponded with his involvement with *The Yellow Book*. The main characteristic of Beardsley's drawings during what has become known as his 'Yellow Book' period was that their subject-matter and settings were usually taken from contemporary life.

The young lady in this drawing is an example of the modern version Beardsley created of the depraved and sensual type of woman who had previously appeared in his work in the guise of historical or literary personages. She is clearly a romanticized prostitute, and Beardsley shared the fascination that prostitutes held for many late nineteenth-century writers and artists, Baudelaire and Zola, Degas and Toulouse-Lautrec among them.

Plate 23. *The Fat Woman.* 1894. Pen, ink and wash, 17·8 × 16·2 cm. London, Tate Gallery.

This splendid image of a procuress or madame seated at a café table (probably the Café Royal) is also a caricature of Whistler's wife. John Lane, understandably, refused to publish it in *The Yellow Book*, which provoked a blandly disingenuous letter from Beardsley, 'I shall most assuredly commit suicide if the Fat Woman does not appear in No. I of "The Yellow Book" . . . All agree that it is one of my best efforts and extremely witty. Really I am sure you have nothing to fear. I should not press the matter a second if I thought it would give offence . . . The picture shall be called "A Study in Major Lines!"' It was eventually published elsewhere and Whistler was offended, and might have been more so, if Beardsley had used his proposed title, a parody of the titles Whistler gave his paintings.

Plate 24. *Mrs Patrick Campbell.* 1894. Drawing for *The Yellow Book*, vol. I. Pen and ink, 33·2 × 21·3 cm. From the line block.

A letter from Beardsley to the actress Mrs Patrick Campbell survives, in which he says, 'It is so good of you to give me a sitting', so this drawing may well have been done from life. However, it is really an elegant caricature and was much objected to, when it appeared in *The Yellow Book*.

Plate 25. Part of the drawing, *L'Education Sentimentale.* April 1894. Pen, ink and watercolour, 27·3 × 8·9 cm. Harvard University, Fogg Art Museum, Grenville L. Winthrop Bequest.

Plate 26. *L'Education Sentimentale.* April 1894. Illustration to the eponymous novel of 1869 by Gustave Flaubert. From *The Yellow Book*, vol. I. From the half-tone plate.

For reasons unknown, Beardsley divided this drawing and only the old woman has survived. This satanically effective image of experience corrupting innocent youth was particularly objected to by critics of *The Yellow Book*.

Plate 27. Design for the frontispiece to *Plays* by John Davidson. 1894. Indian ink over pencil, 28·6 × 18·3 cm. London, Tate Gallery.

This is supposed to be an illustration to the last play in the volume, *Scaramouche in Naxos: A Pantomime*, but all the pantomime figures are caricatures although the identity of some of them has been disputed. The figure in the leopard skin is certainly Oscar Wilde. It is thought that the naked girl is Beardsley's sister Mabel, and that the faun may be Beardsley himself. The significance of this group remains obscure. The figure in the centre is Sir Augustus Harris, a London theatre proprietor, and the masked figure behind is probably the poet Richard Le Gallienne. The identity of the dancer is not known.

Plate 28. *The Wagnerites.* 1894. Indian ink touched with white, 15·6 × 17·8 cm. London, Victoria and Albert Museum.

Reproduced in *The Yellow Book*, vol. III, October 1894. Beardsley adored Wagner and this striking drawing presumably represents his idea of the ideal audience for his operas: one composed predominantly of depraved and sinister viragos.

On the back of the drawing is a note by the artist and critic, Joseph Pennell: 'One of the finest drawings A.B. ever made.'

Plate 29. *The Mysterious Rose Garden.* About 1894–5. Indian ink over pencil, 22·2 × 12·1 cm. Harvard University, Fogg Art Museum, Grenville L. Winthrop Bequest.

Reproduced in *The Yellow Book*, vol. IV, January 1895. It has frequently been pointed out that this drawing is a slightly blasphemous version of the Annunciation.

Plate 30. Drawing for the frontispiece to *A Full and True Account of the Wonderful Mission of Earl Lavender, which Lasted one Night and one Day* by John Davidson. 1895. Pen and ink, 25·7 × 15·7 cm. Harvard University, Fogg Art Museum, Grenville L. Winthrop Bequest.

John Davidson's novel is a satirical account of the practice of flagellation, notoriously well catered for in London at the period and known to French connoisseurs of the erotic as 'le vice anglais'.

Beardsley's frontispiece requires little comment, except perhaps to note the extreme contrast between the delicacy and elegance of Beardsley's drawing, and the activity being depicted. Brian Reade has rightly written that, 'This is . . . one of the most splendid drawings of the nineteenth or any other century'.

Plate 31. *The Third Tableau of Das Rheingold.* 1896. 25·4 × 17·5 cm. From the line block.

One of an uncompleted series of drawings illustrating Wagner's opera. The flame-like draperies of Loge, the figure in the centre, are even more astonishing than in the *Fourth Tableau* (Plate 32).

Plate 32. *The Fourth Tableau of Das Rheingold.* 1896. Pen and ink, 30·5 × 22 cm. London, Victoria and Albert Museum.

One of an uncompleted series of drawings illustrating Wagner's opera. The figure of Loge on the right is notable for Beardsley's rendering of the drapery as a system of astonishing art nouveau swirls.

Plate 33. *Design for the Bookplate of John Lumsden Propert.* 1894. Pen and ink, 19·7 × 11·1 cm. London, Victoria and Albert Museum.

Like many late nineteenth-century artists, Beardsley was fascinated by the idea of women as mysterious goddesses made for man's worship. This drawing is one of his more explicit expressions of this notion.

Plate 34. Cover of *Le Morte d'Arthur.* About 1893–4. Gold stamped on cream cloth. London, Simon Wilson.

The 1890s saw a great renaissance of the art of book design, illustration and decoration. One of the most interesting and significant aspects of this revival was that ordinary commercial publishers began to commission artists to illustrate and decorate their books, using the new photographic means of reproduction, the line block, and decorating cloth covers with stamped or printed designs. A great flood of beautiful books, which now have something of the status of works of art, were produced in this way; and there is no doubt that among cover designs, Beardsley's for *Le Morte d'Arthur* is the outstanding example for the whole period. Totally original in conception, it combines radical simplification and a quite new sense of space with great decorative richness. At the same time these stylized flowers, with their scythe-like leaves and huge fleshy heads, are highly expressive of Beardsley's preoccupation with the sinister and the sensual.

Plate 35. *The Abbé.* About 1895–6. Illustration to *Under the Hill* by Aubrey Beardsley. Pen and ink, 25 × 17·5 cm. London, Victoria and Albert Museum.

In the version of Beardsley's story published in *The Savoy*, the hero is named the Abbé Fanfreluche. In the original manuscript, however, he is called the Abbé Aubrey, and

it seems likely that this drawing is a slightly mocking self-portrait: Beardsley was a great dandy. It illustrates the opening passage of *Under the Hill*: 'The Abbé Fanfreluche, having lighted off his horse, stood doubtfully for a moment beneath the sombre gateway of the mysterious Hill, troubled with an exquisite fear lest a day's travel should have too cruelly undone the laboured niceness of his dress . . . It was taper time; when the tired earth puts on its cloak of mists and shadows . . . when all the air is full of delicate influences . . . and even the beaux, seated at their dressing-tables, dream a little.'

The period of Beardsley's involvement with *The Savoy* marks another change in his style. The illustrations to *Under the Hill*, the covers for *The Savoy* and the illustrations to Pope's *The Rape of the Lock* (Plate 36), all reveal the strong influence of the great Rococo engravers of eighteenth-century France, whose art had always held a vast appeal for Beardsley.

Plate 36. *The Battle of the Beaux and the Belles.* 1896. Illustration to *The Rape of the Lock* by Alexander Pope. Pen and ink, 25·2 × 17·2 cm. Birmingham University, The Barber Institute of Fine Arts.

Beardsley's illustrations to *The Rape of the Lock* have been the most generally admired of all his works, perhaps for their undoubted brilliant skill and relative inoffensiveness. But they lack the powerful originality of his earlier work, an originality that he was to find again before his death in the illustrations to *Lysistrata* (Plates 43, 44, 48, 49).

Plate 37. *Messalina Returning Home.* 1895. Pencil, Indian ink and watercolour, 28 × 17·8 cm. London, Tate Gallery.

One of a number of black and white drawings to which Beardsley later added colour. Here Beardsley has imagined Messalina in a modern city setting, and she becomes another of the women of the night who populate his work during *The Yellow Book* period. (See also note to Plate 39.)

Plate 38. Poster advertising the play, *A Comedy of Sighs*, by John Todhunter at the Avenue Theatre. March 1894. Colour lithograph, 76·2 × 50·8 cm. London, Victoria and Albert Museum.

This poster was Beardsley's most striking contribution to the poster boom of the mid-nineties and aroused much comment with its typical 'Beardsley woman' looming mysteriously through the transparent curtain.

Plate 39. *Messalina Returning from the Bath.* 1897. Illustration to the *Sixth Satire of Juvenal*. Pen and ink, 17·5 × 14·3 cm. London, Victoria and Albert Museum.

Messalina was the third wife of the Roman Emperor Claudius I, and was notorious both for the number of her lovers and for her murderous court intrigues. When the Senator, Appius Silannus, refused her advances, she arranged his death on false charges. She was eventually put to death herself. Beardsley's interest in sinister women would obviously draw him to her as a subject. (See note to Plate 37.)

Plate 40. *The Impatient Adulterer.* 1897. Illustration to the *Sixth Satire of Juvenal*. Pen and ink, 18·2 × 9·8 cm. London, Victoria and Albert Museum.

Beardsley sold this drawing to his friend, Herbert Pollit, and wrote to him:
'The little drawing for Juvenal XI, 237–8, is done.
Abditus interae latet et secretus adulter,
Impatiensque morae pavet et praeputia ducit.
It looks very well; shall I confide it to the post?'
The lines from Juvenal are given in Green's translation (Penguin Classics 1967) as, 'Meanwhile, all hot impatience, hidden behind the scenes, her daughter's lover keeps mum and pulls his wire.' While working on the drawing, Beardsley wrote to his publisher, Leonard Smithers, 'I am doing the adulterer fiddling with his foreskin in impatient expectation – rather a nice picture.'

Pollit evidently appreciated the drawing, for not long after selling it Beardsley wrote to him, 'You are quite right, the Juvenal drawing is admirable. I long to hear of your

having acquired some superb quarto into which it can be bound.' A particularly nice touch is the way Beardsley has drawn the adulterer's toes twisting convulsively together in an agony of impatience.

Plate 41. Cover of *Poor Folk* by F. Dostoevsky, translated by Lena Milman. 1894. Printed cloth. Cover of *The Dancing Faun* by Florence Farr, 1894. Printed cloth. Each 20 × 13 cm. London, Simon Wilson.

Two volumes from the 'Keynotes' series of novels and short stories published by John Lane and others in London, Bolton and New York. Beardsley designed cover and title pages for 22 of the 34 volumes in the series, and decorative keys, embodying the author's initials, for the spines of 15.

The design for *Poor Folk* is a fine example of Beardsley's 'Yellow Book' style, with its bold massing of blacks and modern setting. In particular the decorative use of a drainpipe is without precedent in art, and looks forward to the use of such motifs by the 'Pop' artists sixty years later.

The faun in the design for *The Dancing Faun* is a caricature of the artist Whistler, whom Beardsley disliked, although the book has nothing to do with Whistler.

The 'Keynotes' series made contemporary fiction available in cheap editions which were also attractive and well designed.

Plate 42. Cover of *The Mirror of Music* by Stanley Mackower. 1895. Printed cloth. Cover of *The Mountain Lovers* by Fiona MacLeod. 1895. Printed cloth. Each 20 × 13 cm. London, Simon Wilson.

Two of the 'Keynotes' series of novels and short stories published by John Lane. (See note to Plate 41.)

Plate 43. *The Toilet of Lampito.* 1896. Illustration for *The Lysistrata of Aristophanes.* Indian ink with traces of pencil, 26 × 17·8 cm. London, Victoria and Albert Museum.

In his drawings for *Lysistrata*, Beardsley returned to a purely linear style, which is a development of the manner of the *Salomé* drawings. New is the consistent use of dramatic blank backgrounds, the closed linearity of the figures, their greater naturalism and the much reduced, but highly effective, use of decorative masses of black. It has frequently been pointed out that, both in style and in subject matter, these drawings reveal the influence of Greek vase painting, which Beardsley is known to have studied in the British Museum in 1894, but as usual with Beardsley the total effect is unique in art.

The Toilet of Lampito is certainly the most directly and explicitly erotic of all Beardsley's drawings. It appears to have no direct source in the text of the play.

Plate 44. *Two Athenian Women in Distress.* 1896. Illustration for *The Lysistrata of Aristophanes.* From a collotype. London, Victoria and Albert Museum.

One of the most formally daring of Beardsley's designs for *Lysistrata*, with the arm entering from the top edge of the composition. The marvellous black stockings are less ancient Greek than modern Parisian.

Plate 45. Cover of *The Houses of Sin* by Vincent O'Sullivan published by Leonard Smithers, London 1897. Gold stamped on parchment board, 23 × 14·5 cm. London, Simon Wilson.

A strange, sumptuous and sinister design that is a virtuoso example of Beardsley's ability to organize space and mass into striking abstract patterns. Like the design for Dowson's *Verses* (Plate 46), this is one of Beardsley's finest book covers, especially notable for its eccentric, narrow, upright format.

Plate 46. Cover of *Verses* by Ernest Dowson, published by Leonard Smithers, London, 1896. Gold stamped on parchment board, 19·8 × 15·3 cm. London, Robert M. Booth.

Undoubtedly the simplest, most elegant and most brilliantly abstract of Beardsley's many book covers.

Plate 47. Cover of *The Yellow Book*, vol. I, April 1894, and vol. II, July 1894. Printed cloth, 20·7 × 17 cm. London, Simon Wilson.

Much more than the literary contents, it was Beardsley's cover designs and drawings which were the cause of the immense notoriety of the first few issues of *The Yellow Book*.

Plate 48. *Cineseas Entreating Myrrhina to Coition.* 1896. Illustration for *The Lysistrata of Aristophanes*. Indian ink with traces of pencil, 26 × 17·8 cm. London, Victoria and Albert Museum.

In one of the funniest scenes in Aristophanes' play, Cineseas returns from the fighting and attempts to claim his marital dues, which his wife Myrrhina staunchly refuses.

Plate 49. *The Lacedaemonian Ambassadors.* 1896. Illustration for *The Lysistrata of Aristophanes*. Indian ink with traces of pencil, 26 × 17·8 cm. London, Victoria and Albert Museum.

This drawing, although startling, is in fact a quite literal illustration of Aristophanes' text.

Plate 50. *Isolde.* Colour lithograph published as a supplement to *The Studio*, October 1895. 22·9 × 14·3 cm.

A characteristic Beardsley caprice, in which one of his favourite Wagner heroines is seen as a woman of his own period.

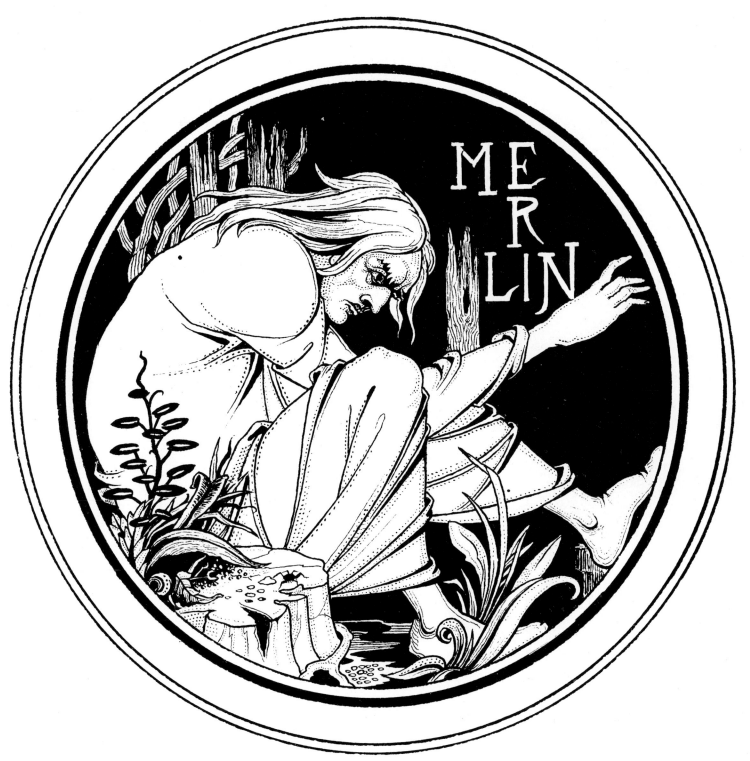

1. *Merlin*. About 1893–4. Pen and ink. Washington, Library of Congress, Rosenwald Collection

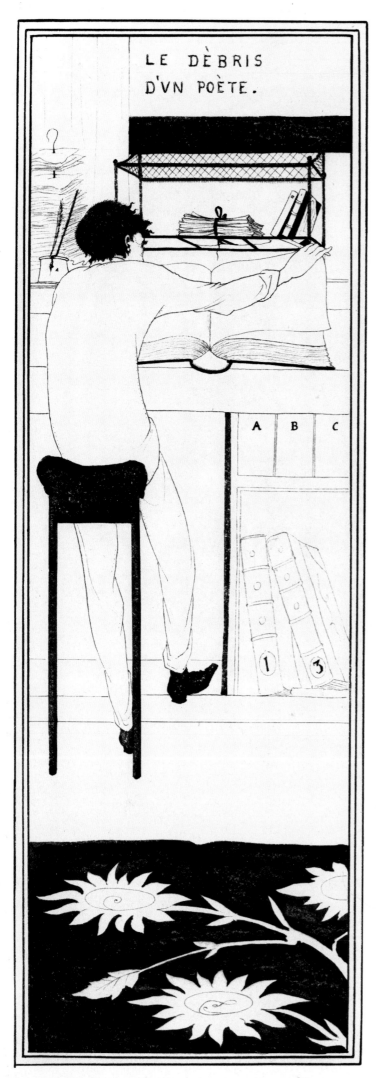

2. *Le Dèbris d'un Poète* (The Remains of a Poet). 1892. Pen and ink. London, Victoria and Albert Museum

3. *How King Arthur Saw the Questing Beast*. 1893. Pen and ink. London, Victoria and Albert Museum

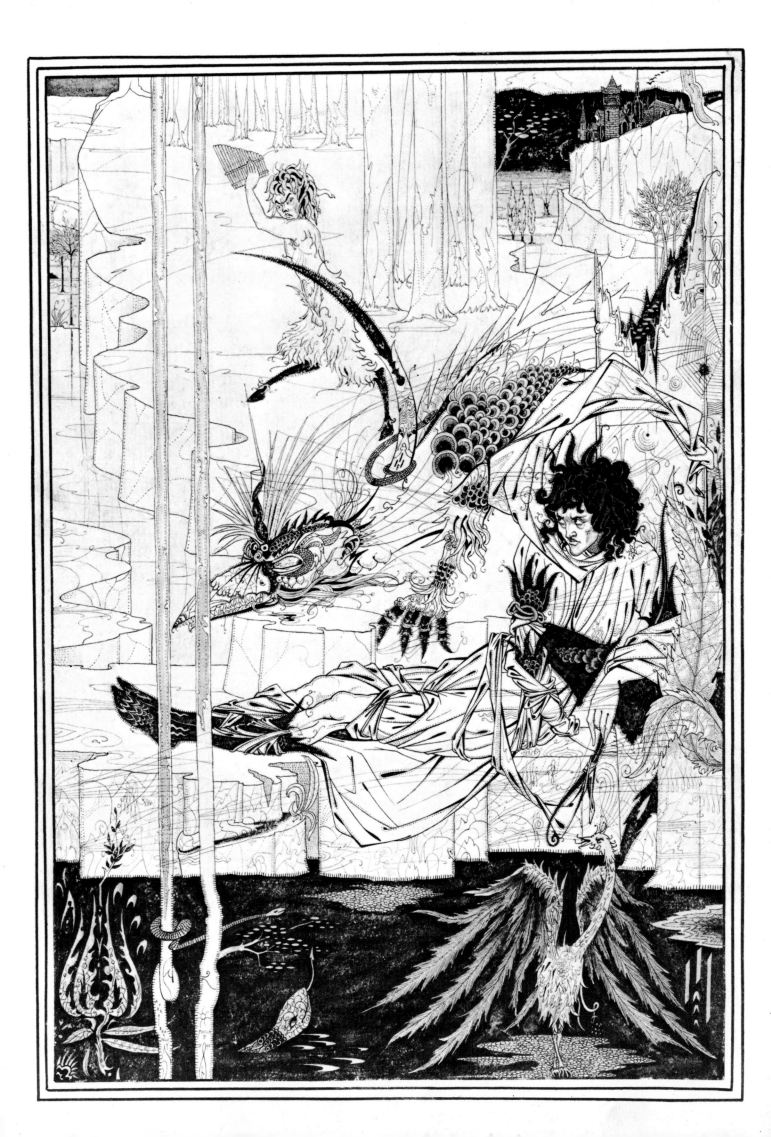

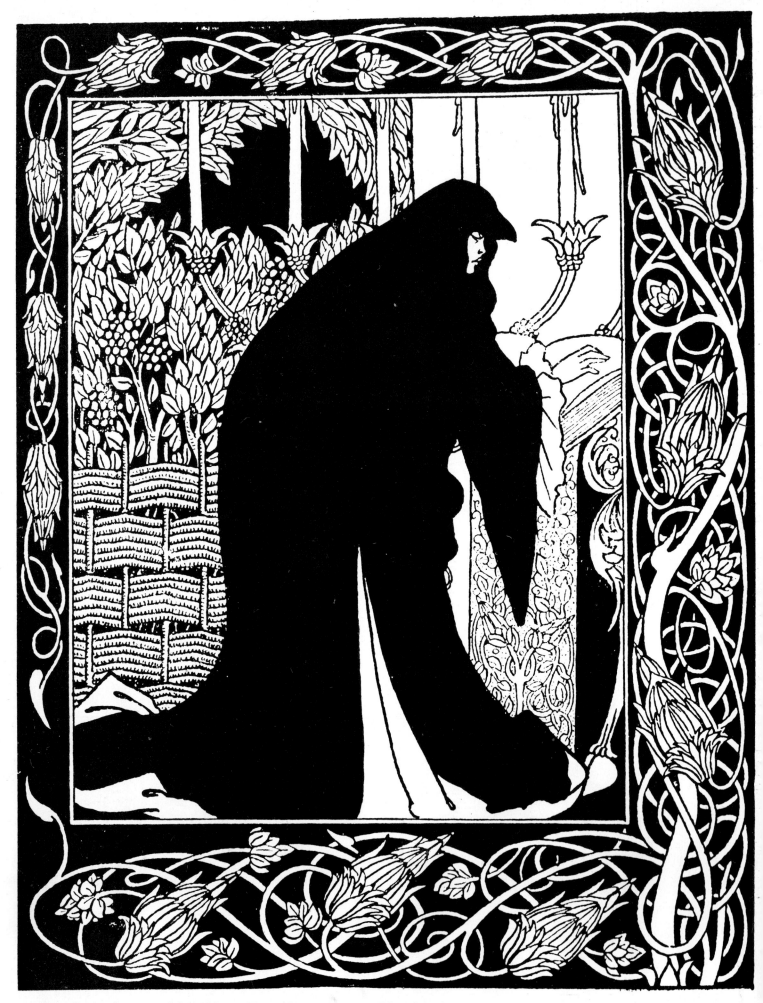

4. *How Queen Guenever Made Her a Nun.* About 1893–4. Line block

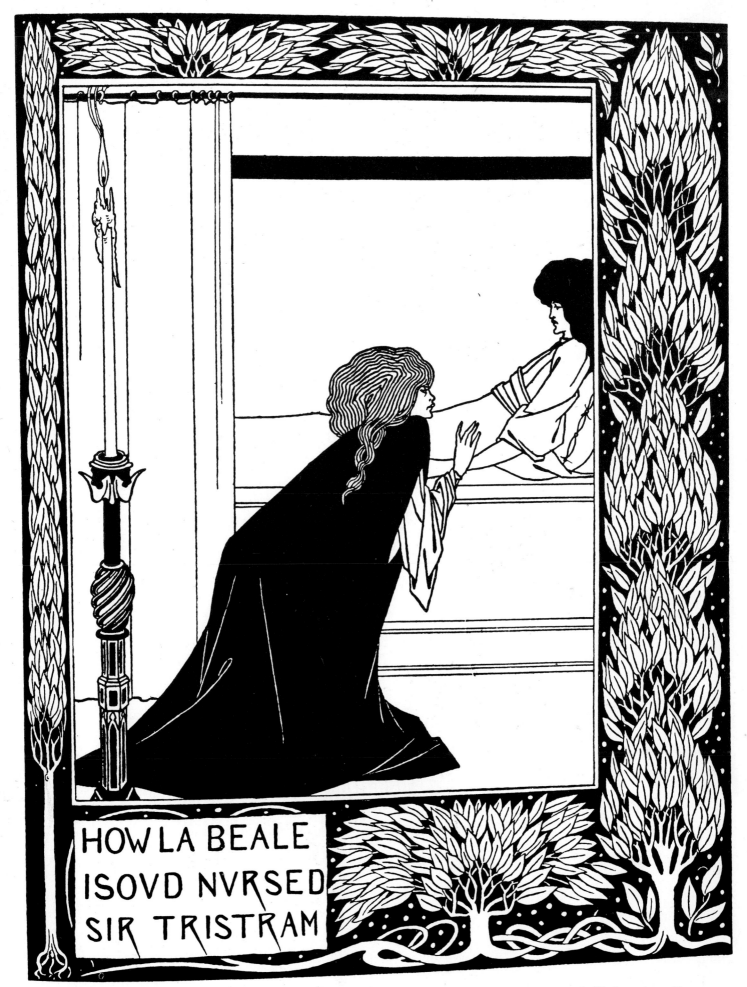

How La Beale Isoud Nursed Sir Tristram

5. *How La Beale Isoude Nursed Sir Tristram*. About 1893–4. Pen and ink. Harvard University, Fogg Art Museum, Scofield Thayer Collection

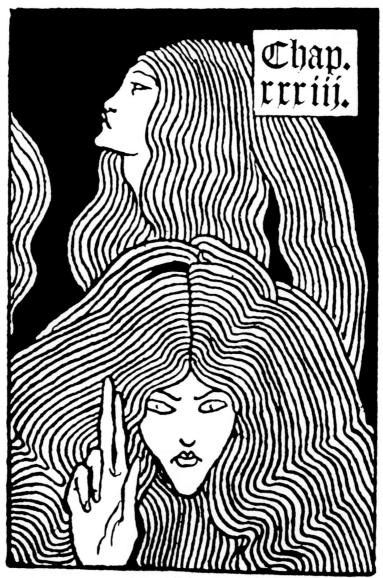

6. Heading of Chapter XXXIII in *Le Morte d'Arthur*.
About 1893–4. Line block

7. Heading of Chapter XIV in *Le Morte d'Arthur*. About 1893–4.
Line block

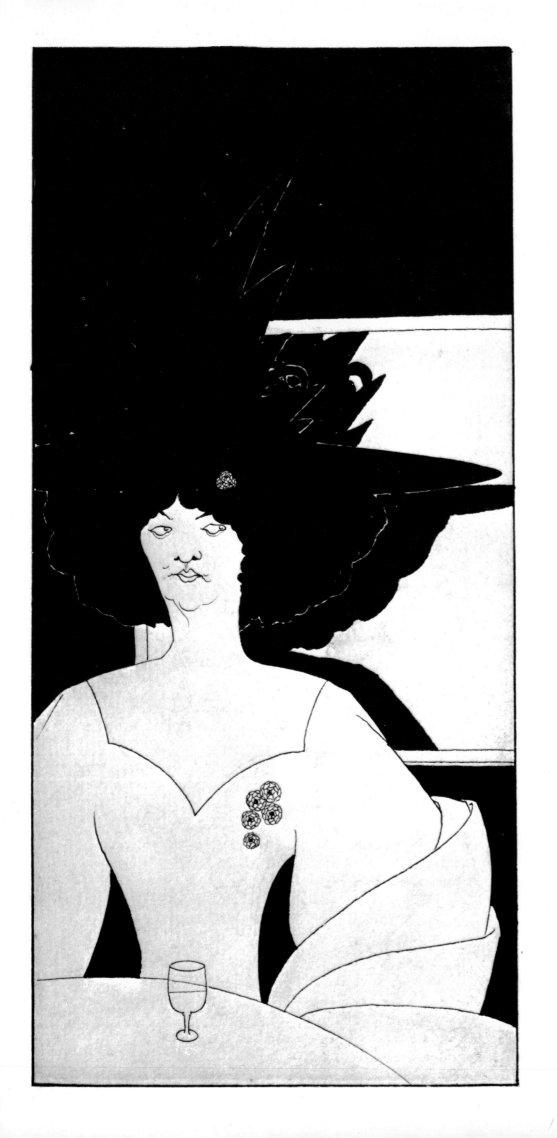

9. Vignette for *Bon-Mots of Smith and Sheridan*. 1893. Pen and ink. London, Victoria and Albert Museum

8. *Woman in Café* or *Waiting*. About 1893–4. Pen and ink. London, Brian Reade

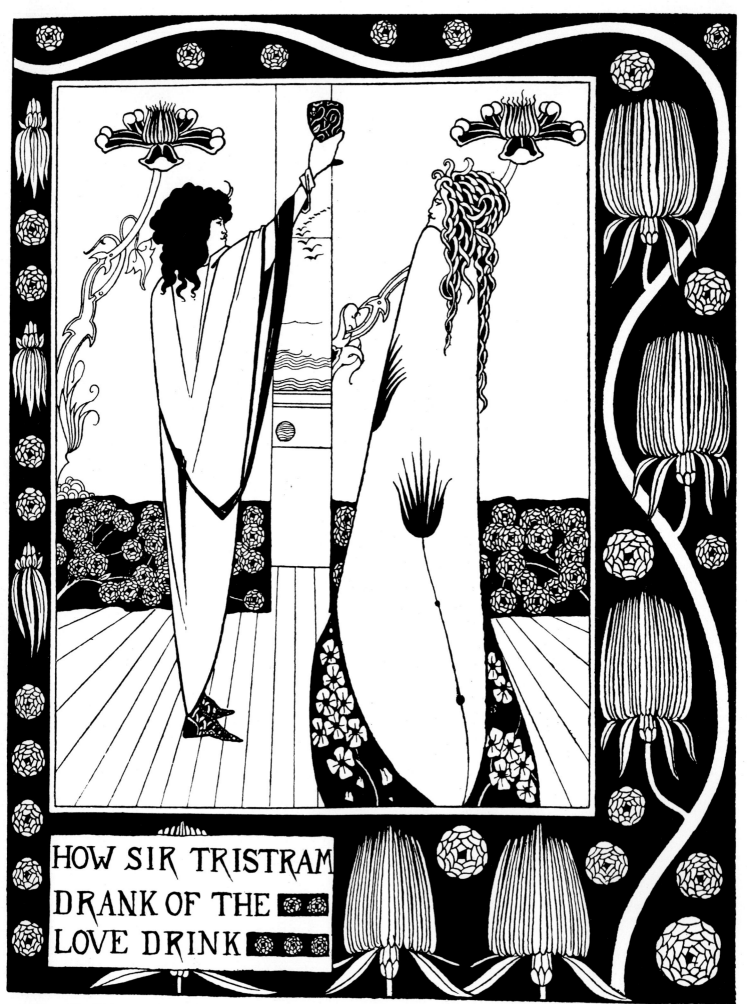

10. *How Sir Tristram Drank of the Love Drink*. About 1893–4. Pen and ink. Harvard University, Fogg Art Museum, Scofield Thayer Collection

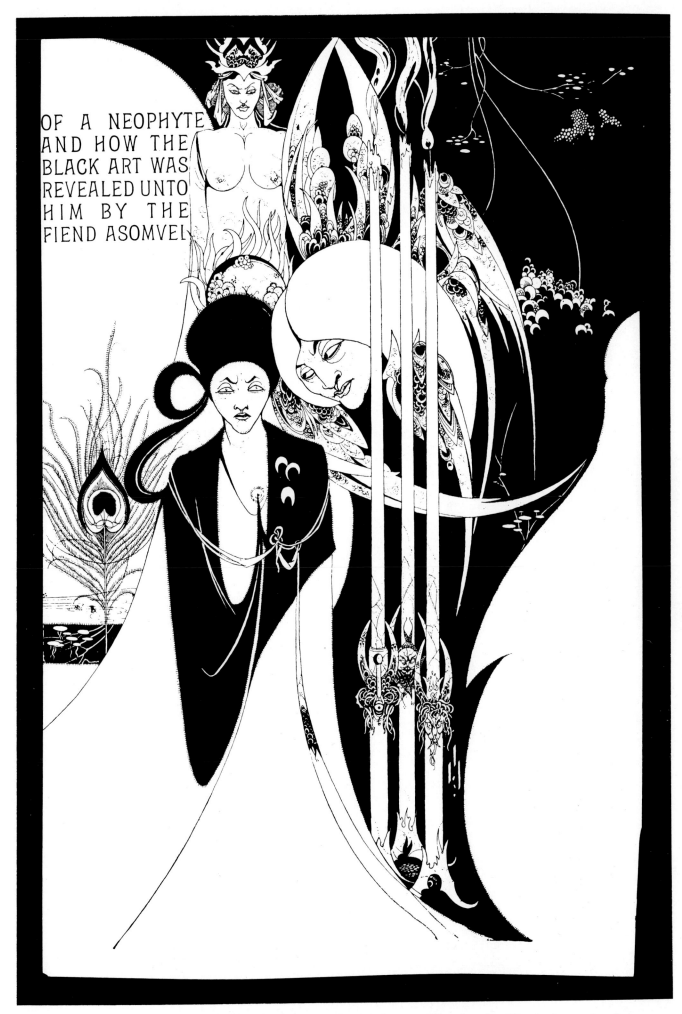

OF A NEOPHYTE
AND HOW THE
BLACK ART WAS
REVEALED UNTO
HIM BY THE
FIEND ASOMVEL

11. *Of a Neophyte and How the Black Art was Revealed unto Him by the Fiend Asomuel.* 1893. Line block

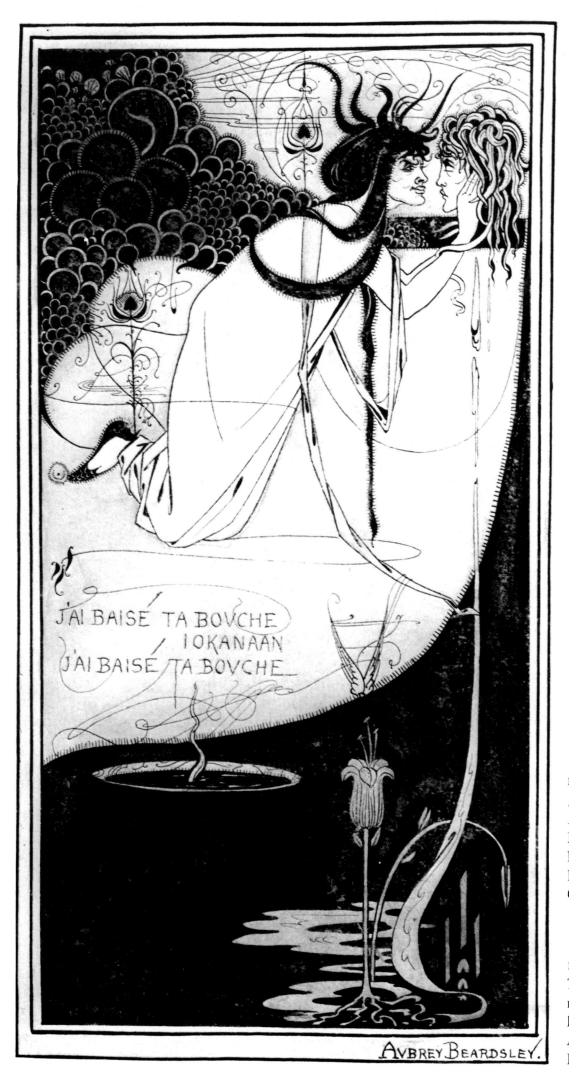

J'AI BAISÉ TA BOVCHE
IOKANAÄN
J'AI BAISÉ TA BOVCHE

AVBREY BEARDSLEY.

12.
J'ai Baisé ta Bouche,
Iokanaan (I have Kissed thy
Mouth, Iokanaan). 1893.
Pen, ink and watercolour.
Princeton University Library
Gallatin Beardsley Collection

13.
The Woman in the Moon.
1894. Pencil and ink.
Harvard University, Fogg
Art Museum, Grenville
L. Winthrop Bequest

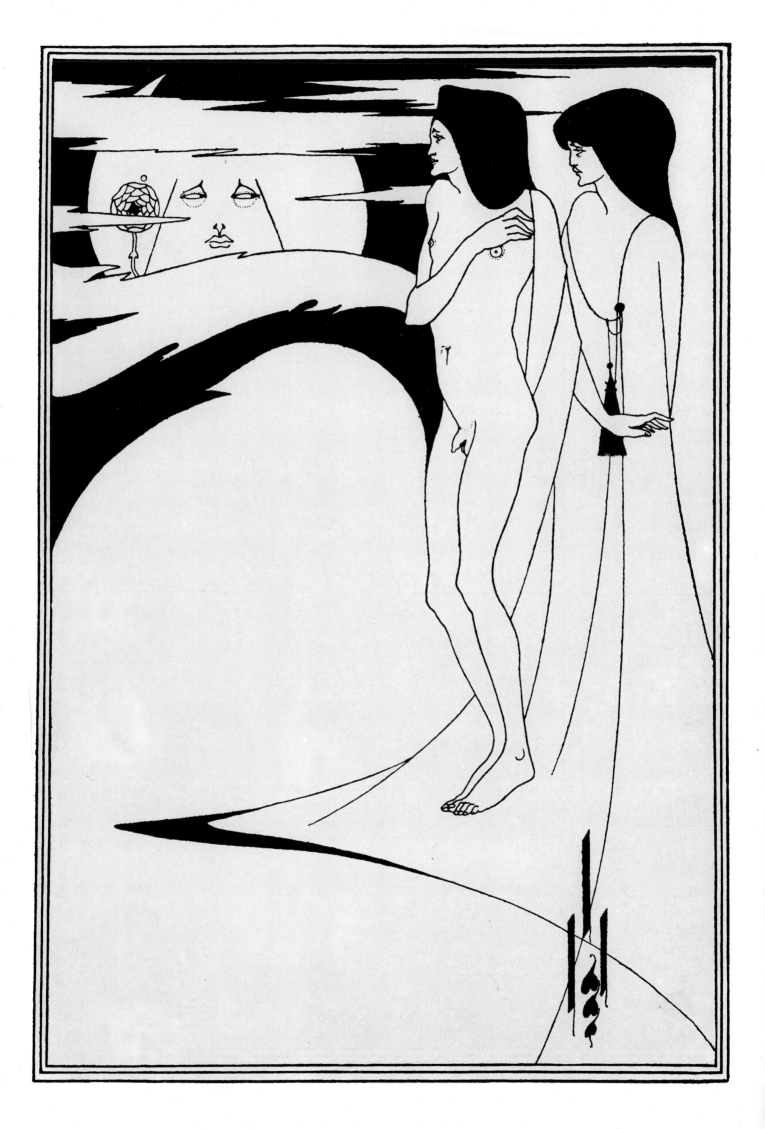

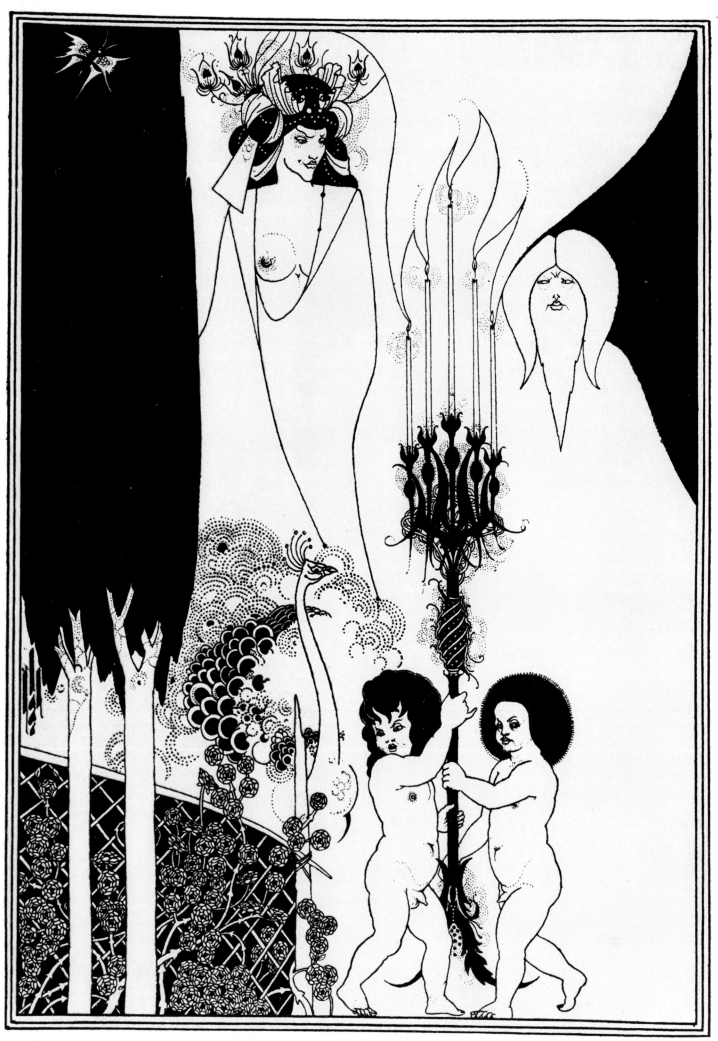

14. *The Eyes of Herod.* 1894. Pencil and ink. Harvard University, Fogg Art Museum, Grenville L. Winthrop Bequest

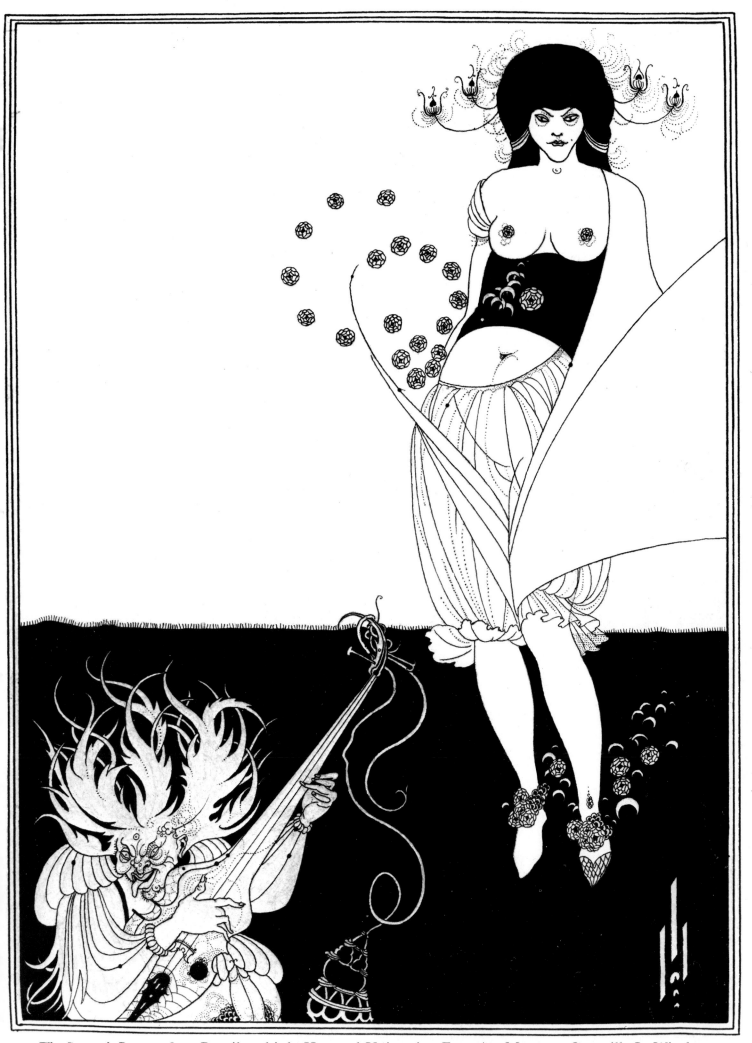

15. *The Stomach Dance.* 1894. Pencil and ink. Harvard University, Fogg Art Museum, Grenville L. Winthrop Bequest

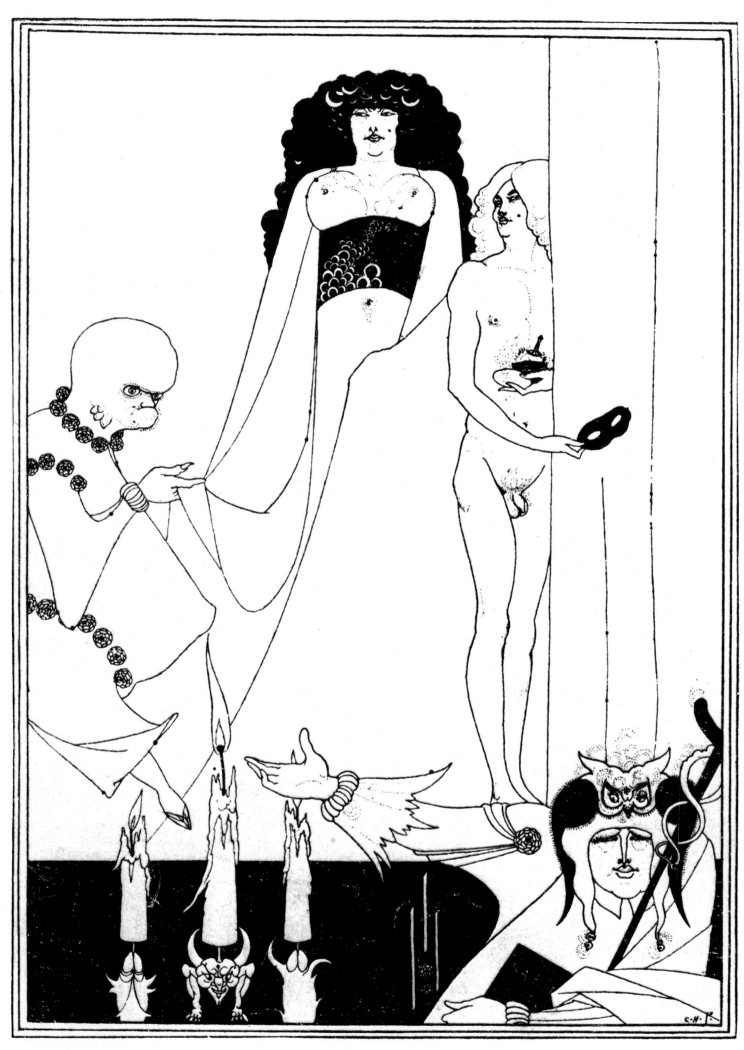

16. *Enter Herodias*. 1894. Line block. Princeton University Library, Gallatin Beardsley Collection

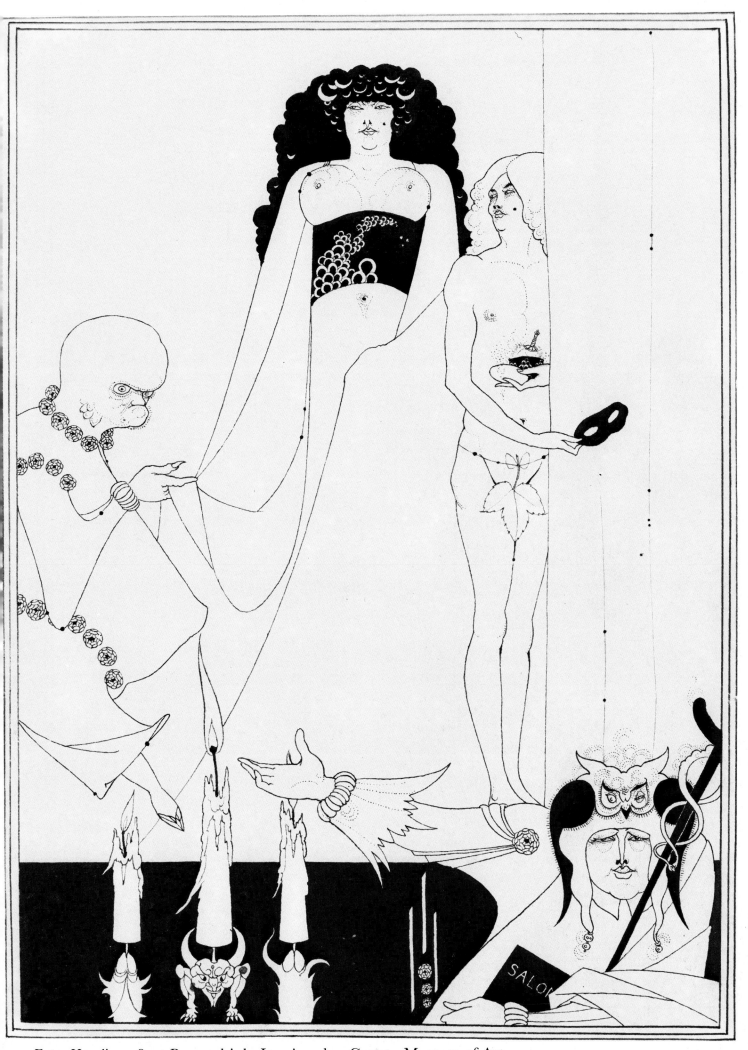

17. *Enter Herodias*. 1893. Pen and ink. Los Angeles, County Museum of Art

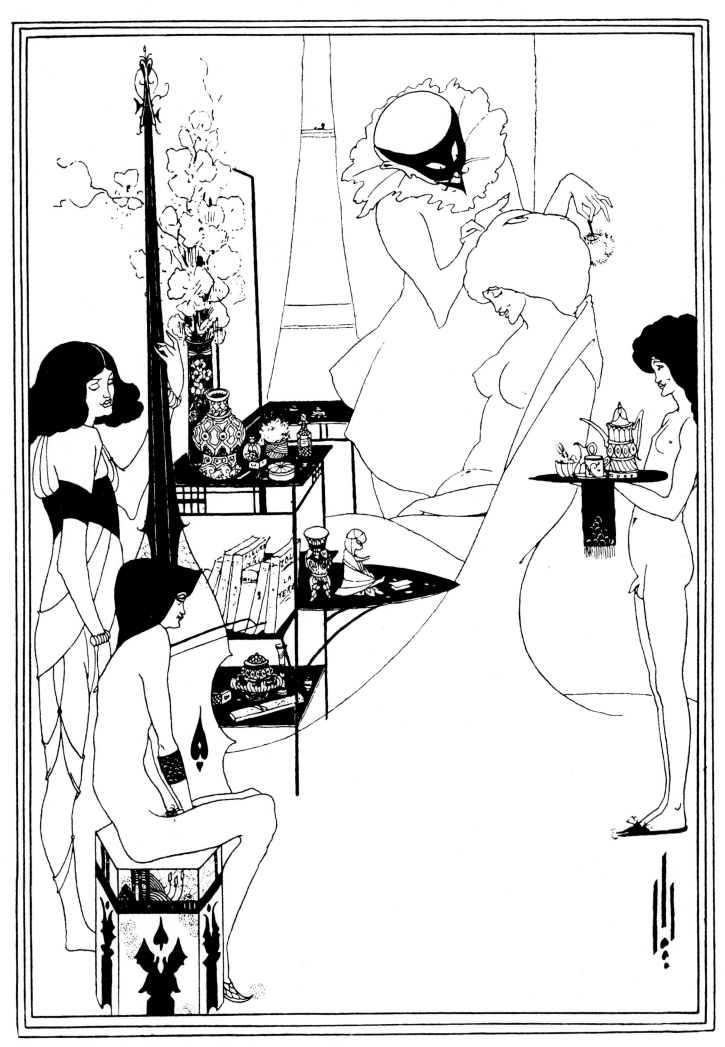

18. *The Toilet of Salome.* 1894. Line block

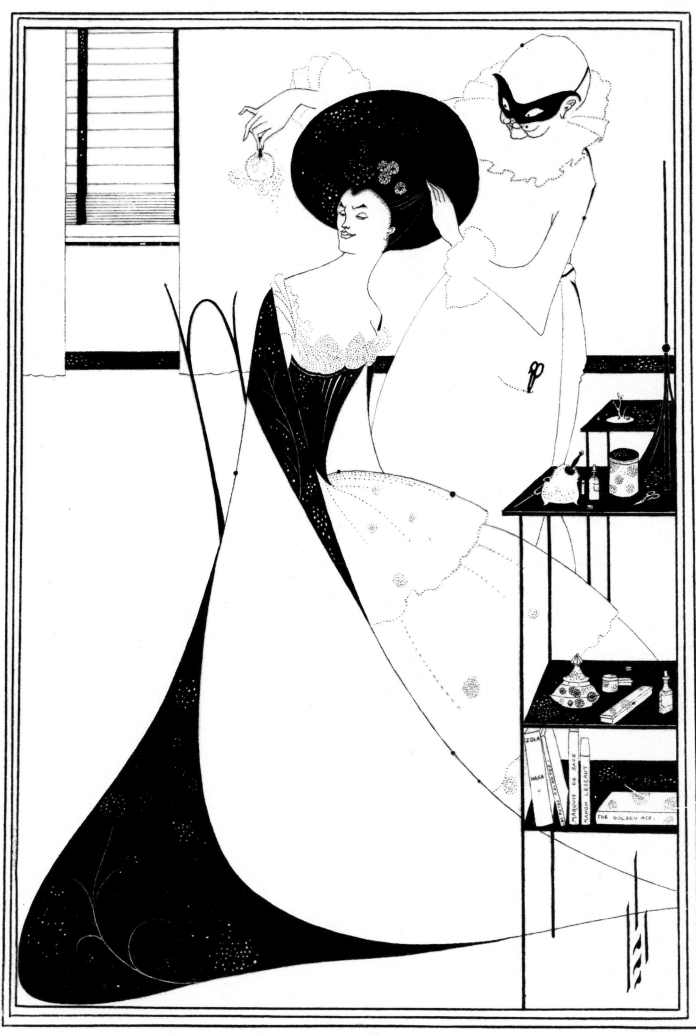

19. *The Toilet of Salome.* 1894. Pencil and ink. London, British Museum

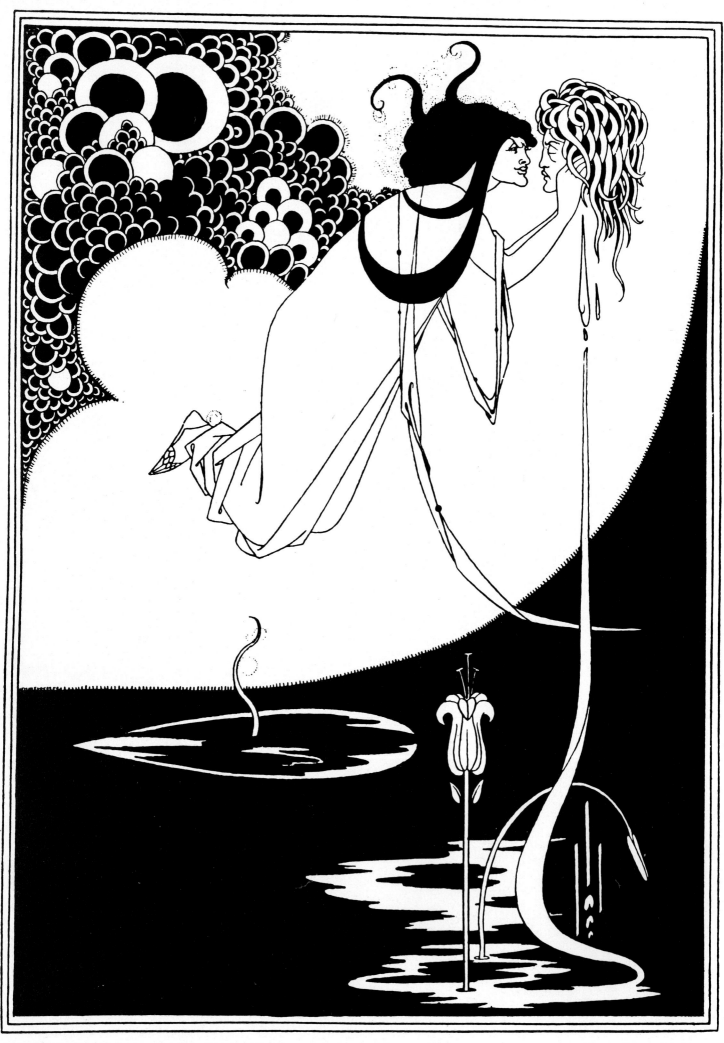

20. *The Climax*. 1894. Line block

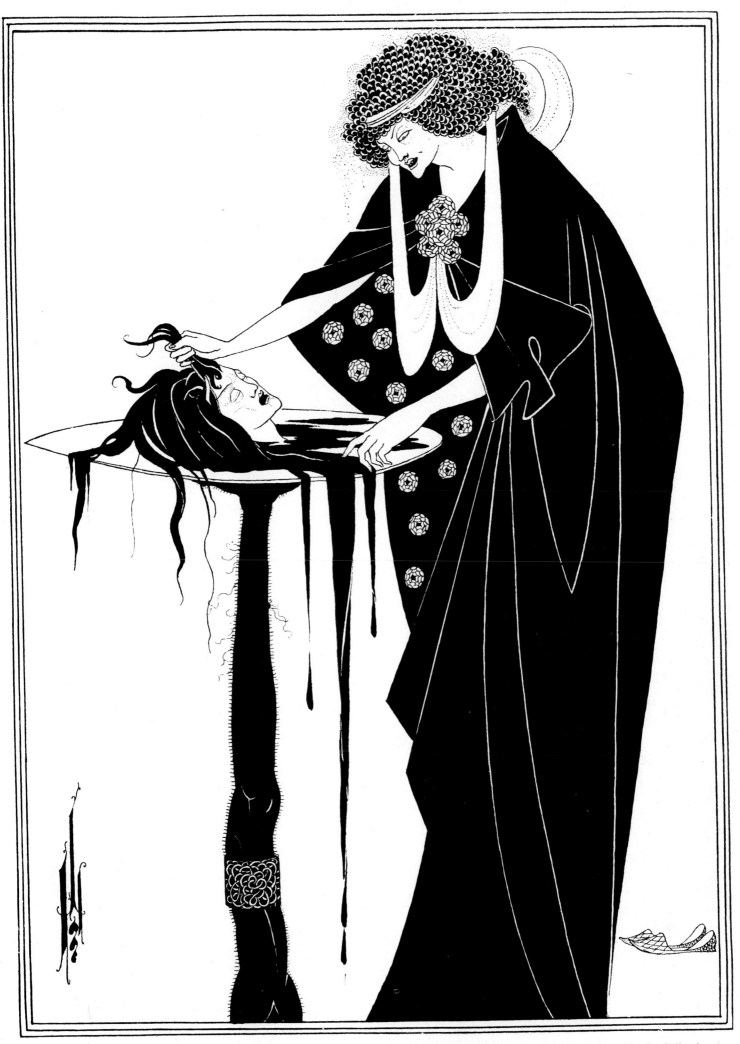

21. *The Dancer's Reward*. 1894. Pencil and ink. Harvard University, Fogg Art Museum, Grenville L. Winthrop Bequest

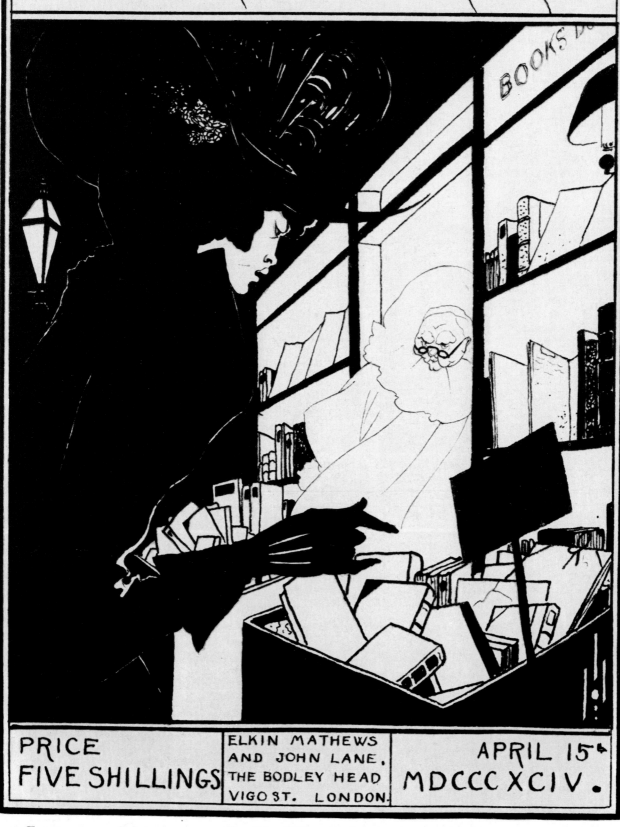

22. Front cover of the prospectus for *The Yellow Book*. 1894. Ink. London, Victoria and Albert Museum

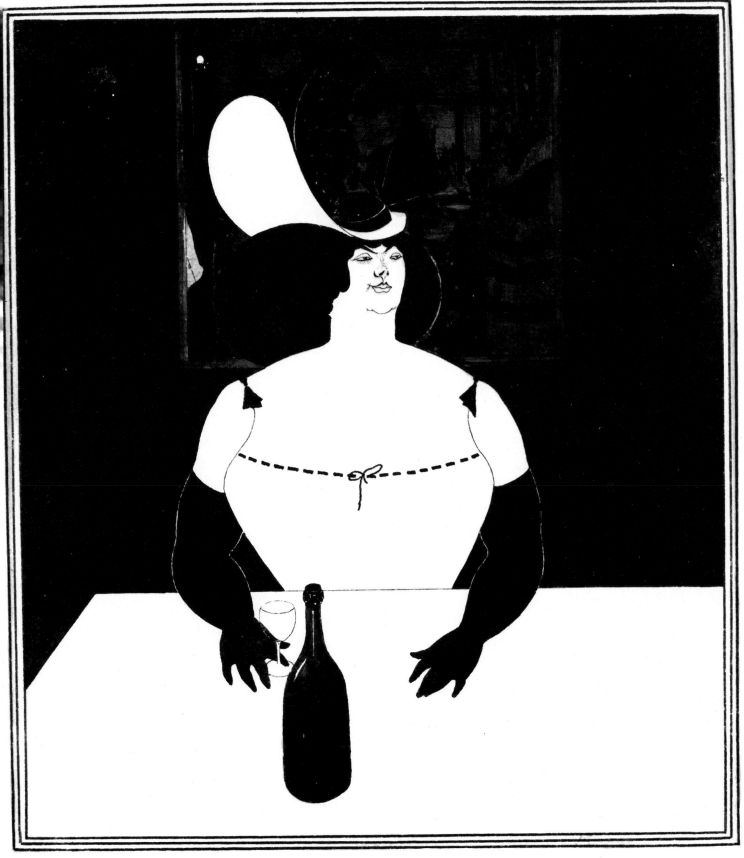

23. *The Fat Woman.* 1894. Pen, ink and wash. London, Tate Gallery

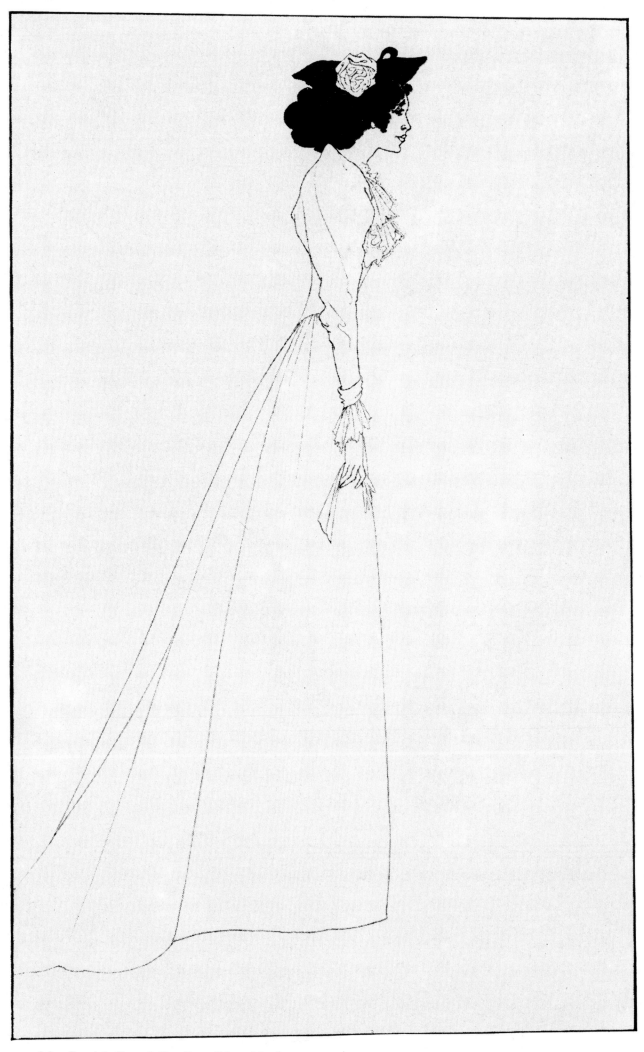

24. *Mrs Patrick Campbell*. 1894. Line block

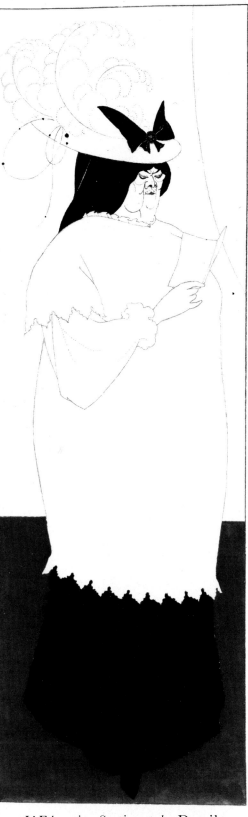

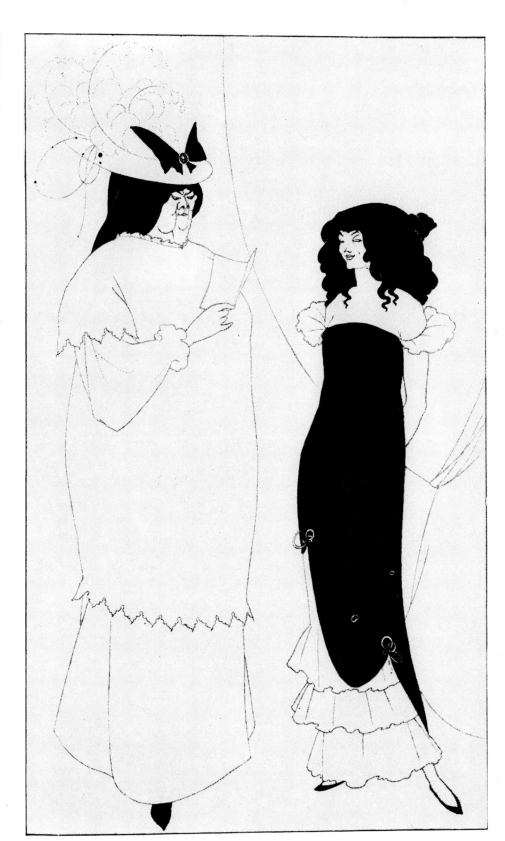

25. *L'Education Sentimentale*. Detail. 1894. Pen, ink and watercolour. Harvard University, Fogg Art Museum, Grenville L. Winthrop Bequest

26. *L'Education Sentimentale*. 1894. Half-tone plate

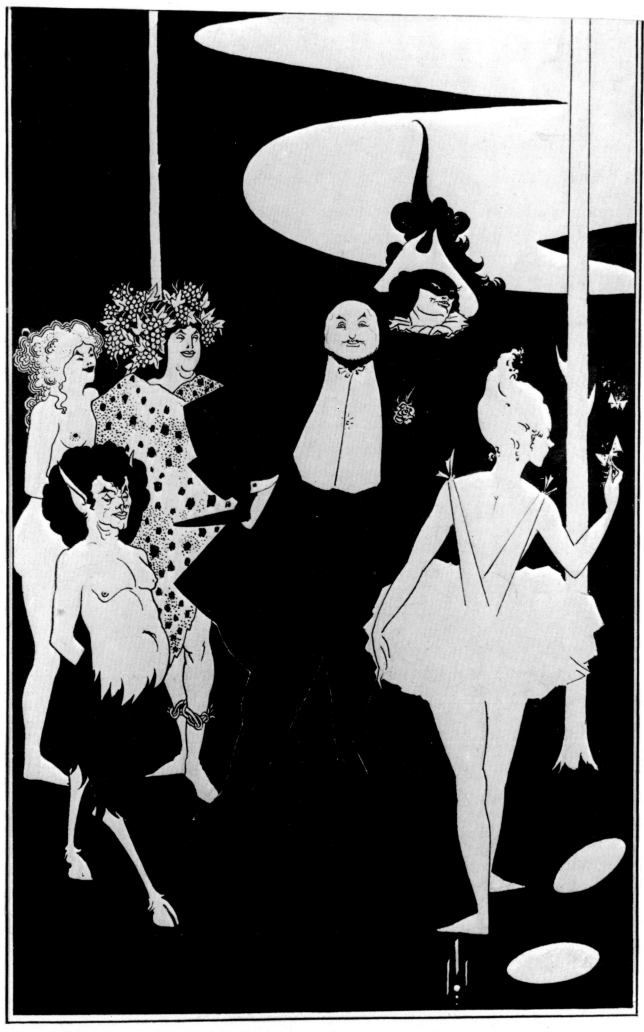

27. Design for the frontispiece to *Plays*. 1894. Pencil and ink. London, Tate Gallery

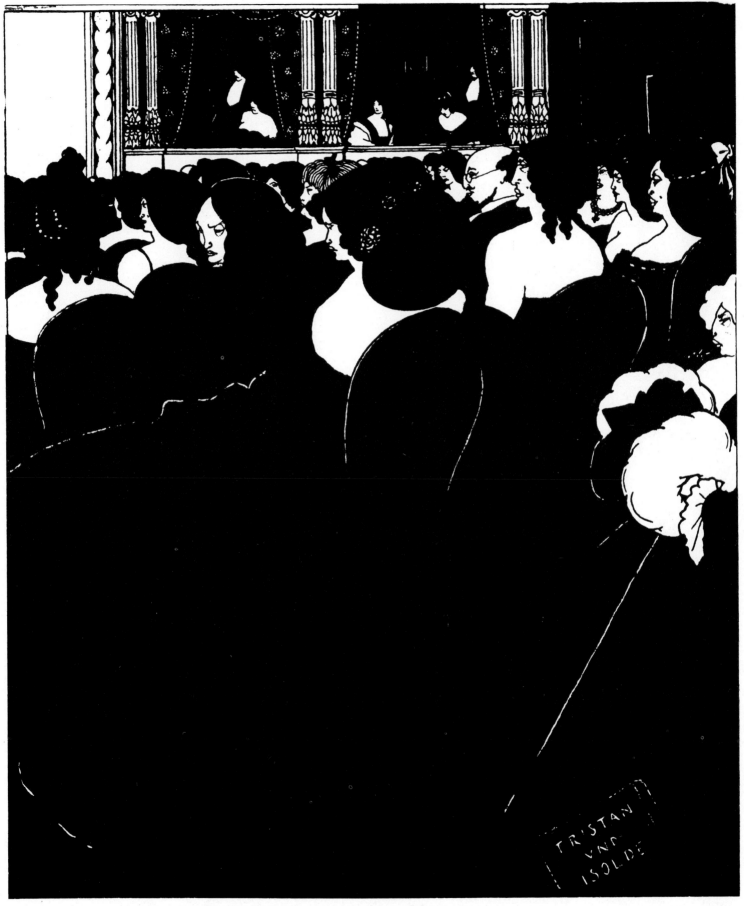

28. *The Wagnerites*. 1894. Ink. London, Victoria and Albert Museum

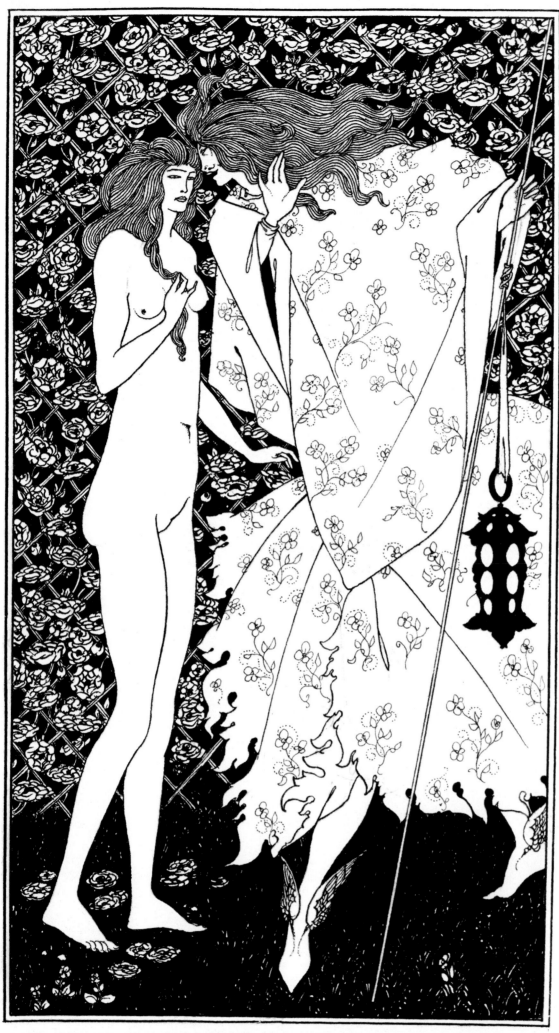

29. *The Mysterious Rose Garden.* About 1894–5. Pencil and ink. Harvard
University, Fogg Art Museum, Grenville L. Winthrop Bequest

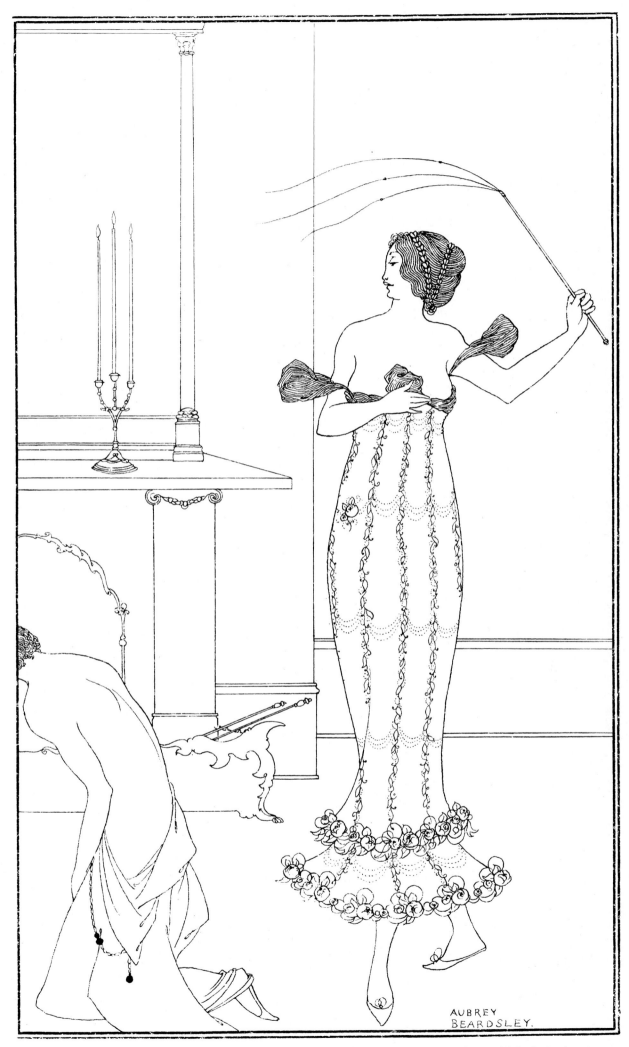

30. *A Full and True Account of the Wonderful Mission of Earl Lavender, which Lasted one Night and one Day.* 1895. Pen and ink. Harvard University, Fogg Art Museum, Grenville L. Winthrop Bequest

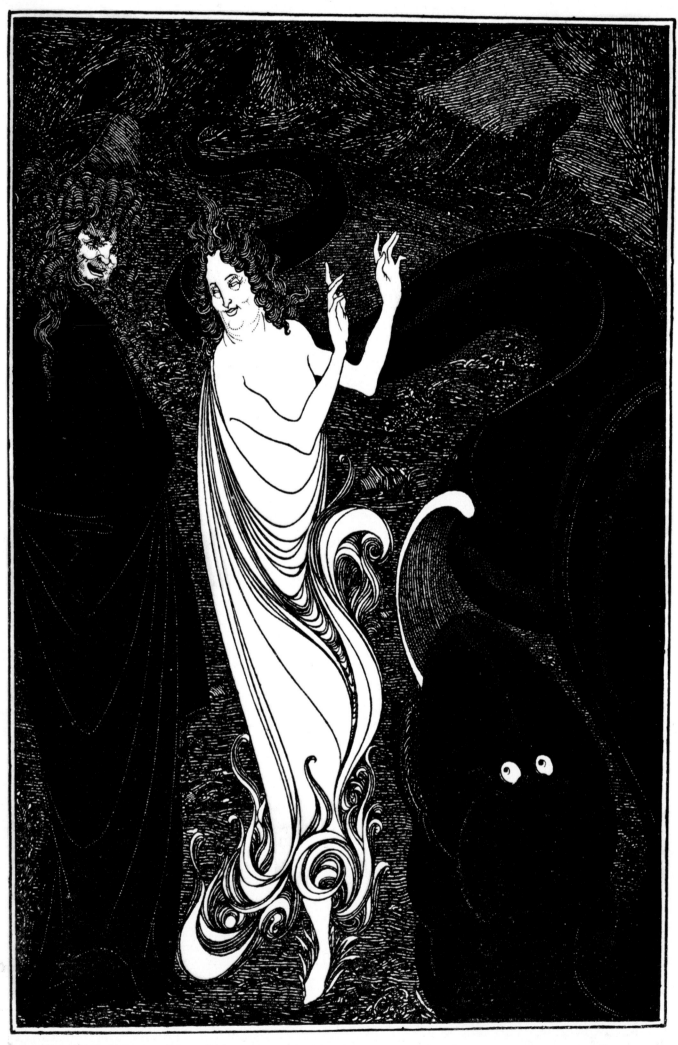

31. *The Third Tableau of Das Rhinegold*. 1896. Line block

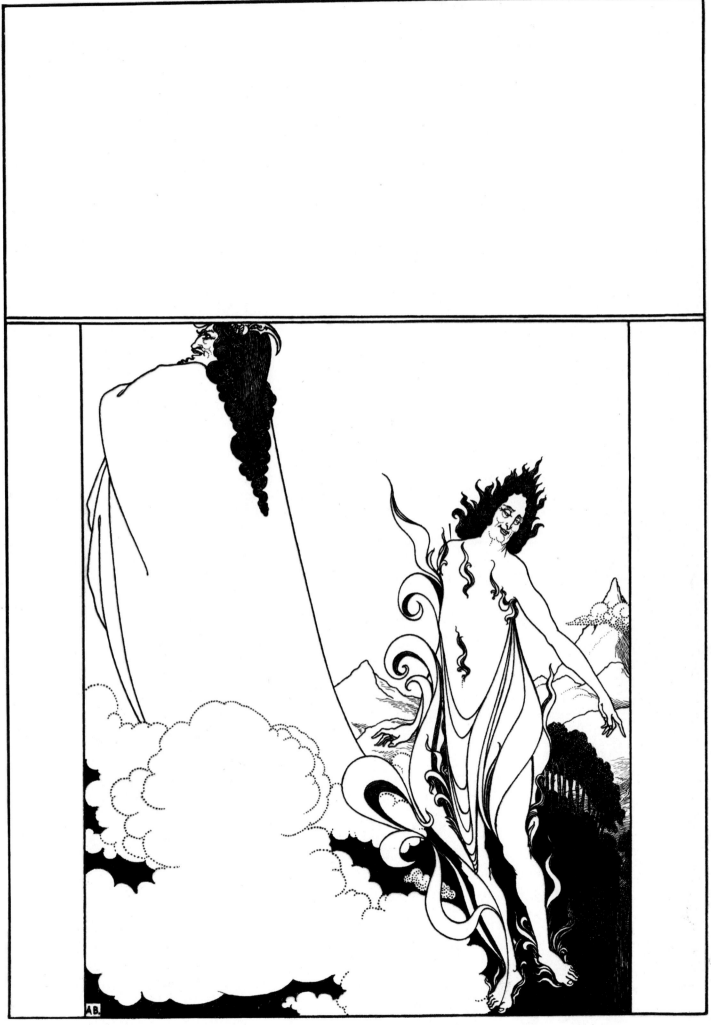

32. *The Fourth Tableau of Das Rhinegold.* 1896. Pen and ink. London, Victoria and Albert Museum

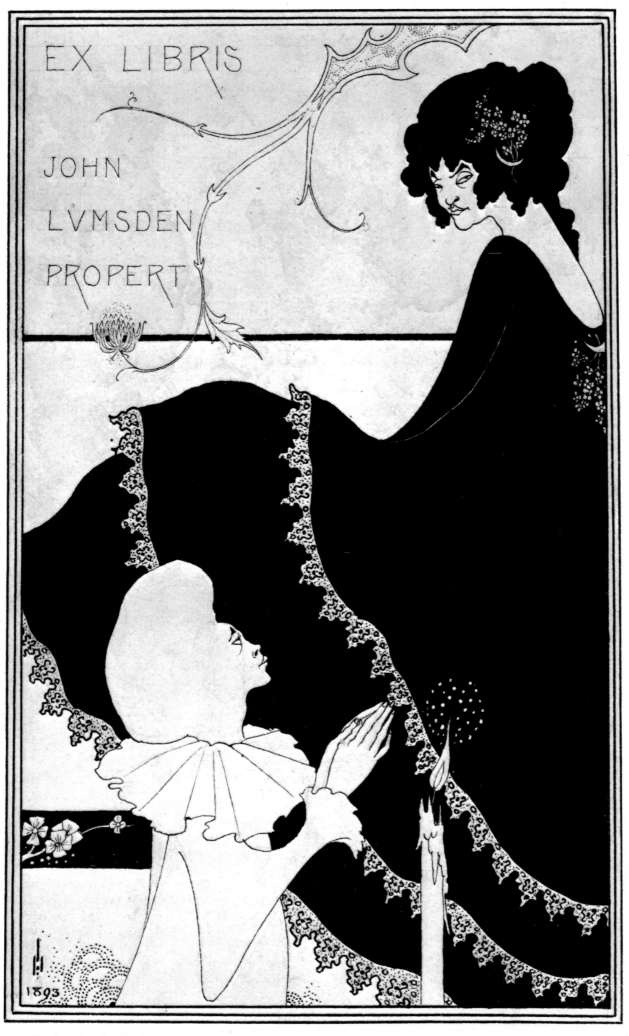

EX LIBRIS

JOHN
LVMSDEN
PROPERT

33. *Design for the Bookplate of John Lumsden Propert.* 1894. Pen and ink. London, Victoria and Albert Museum

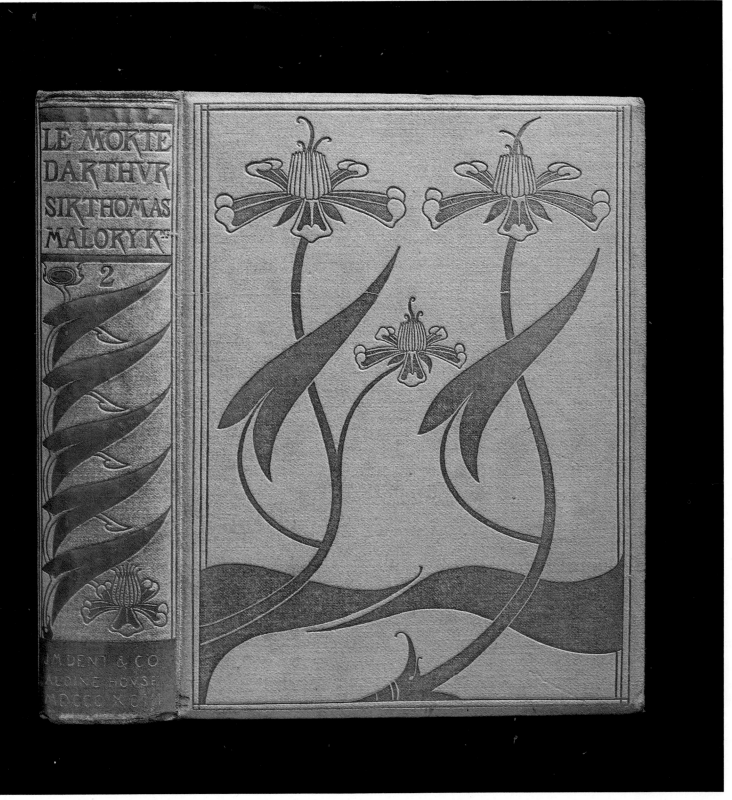

34. Cover of *Le Morte d'Arthur*. About 1893–4. Cloth. London, Simon Wilson

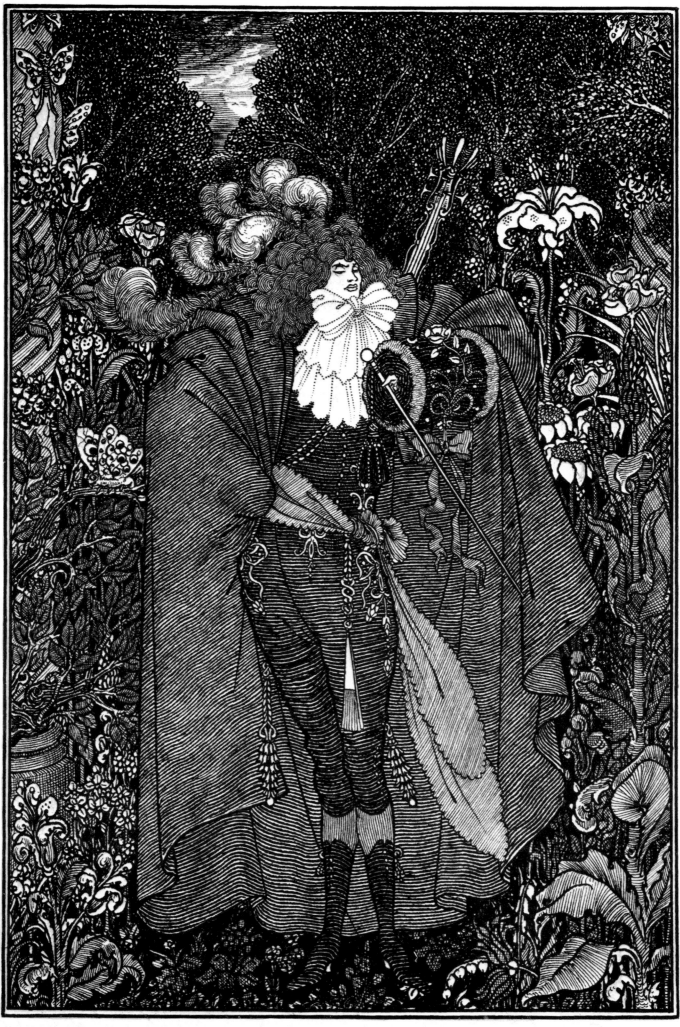

35. *The Abbé*. About 1895–6. Pen and ink. London, Victoria and Albert Museum

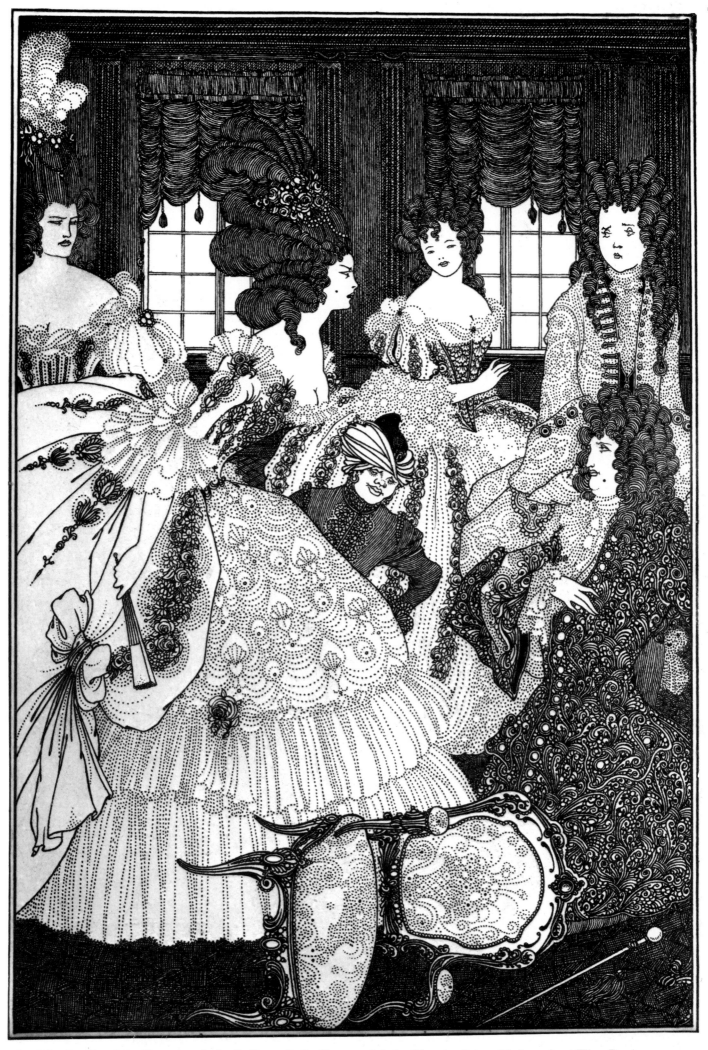

36. *The Battle of the Beaux and the Belles.* 1896. Pen and ink. Birmingham University, The Barber Institute of Fine Arts

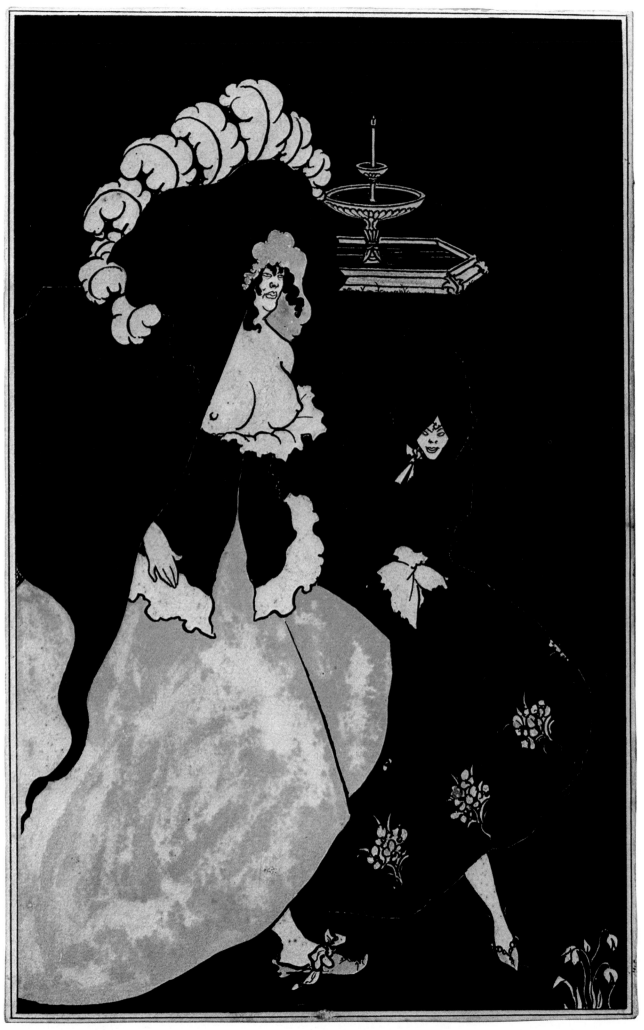

37. *Messalina Returning Home.* 1895. Pen, ink and watercolour. London, Tate Gallery

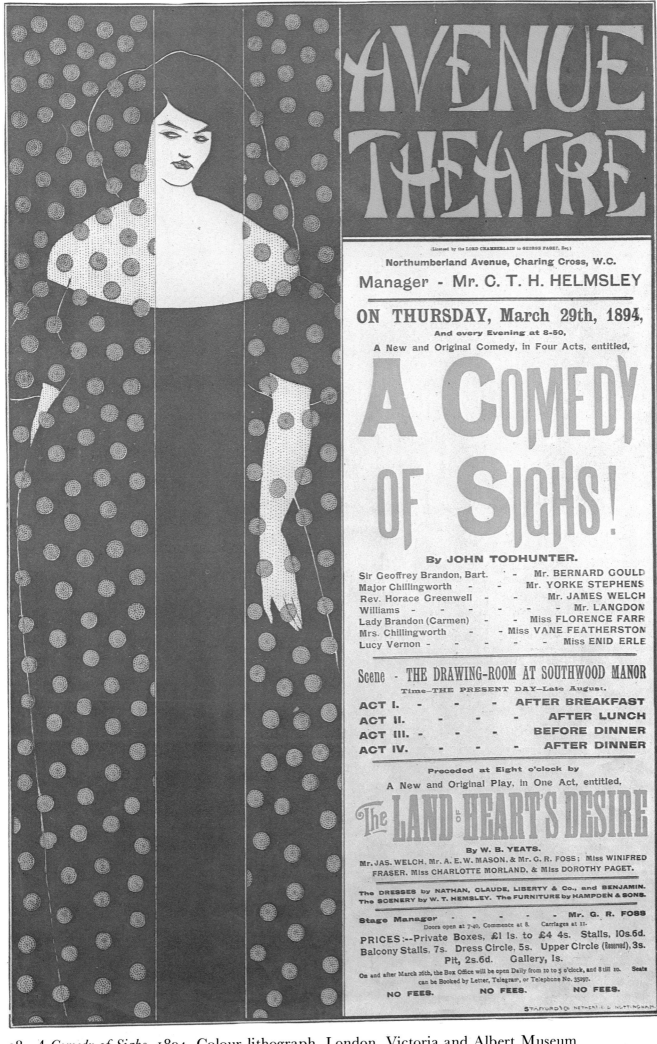

38. *A Comedy of Sighs*. 1894. Colour lithograph. London, Victoria and Albert Museum

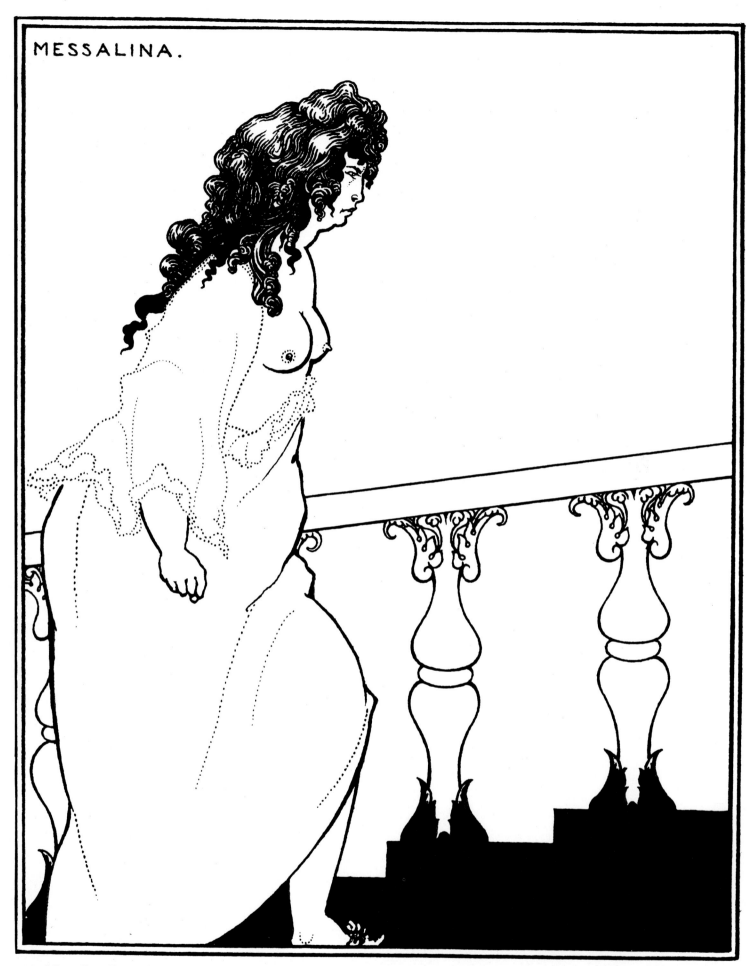

MESSALINA.

39. *Messalina Returning from the Bath.* 1897. Pen and ink. London, Victoria and Albert Museum

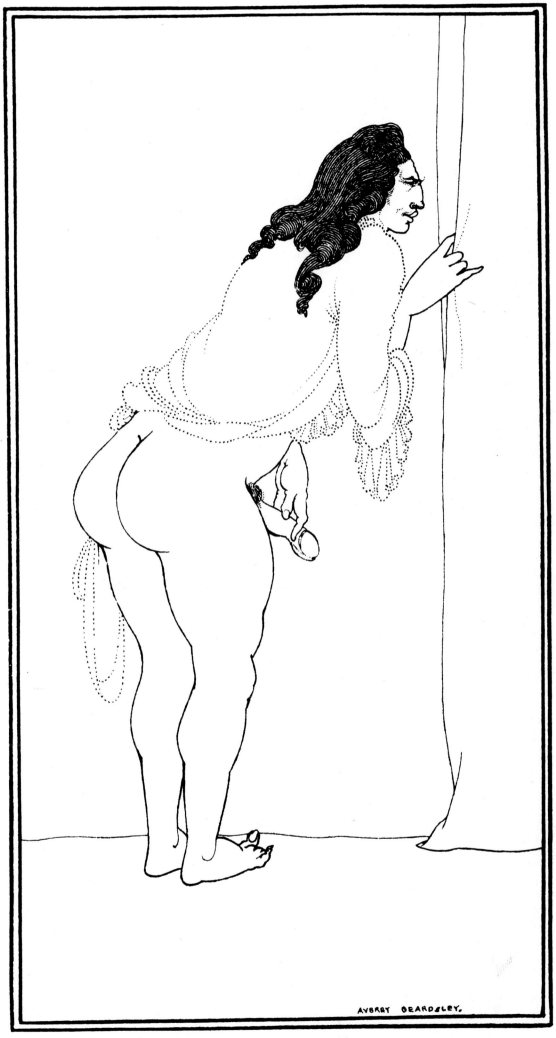

AVBREY BEARDSLEY.

40. *The Impatient Adulterer.* 1897. Pen and ink. London, Victoria and Albert Museum

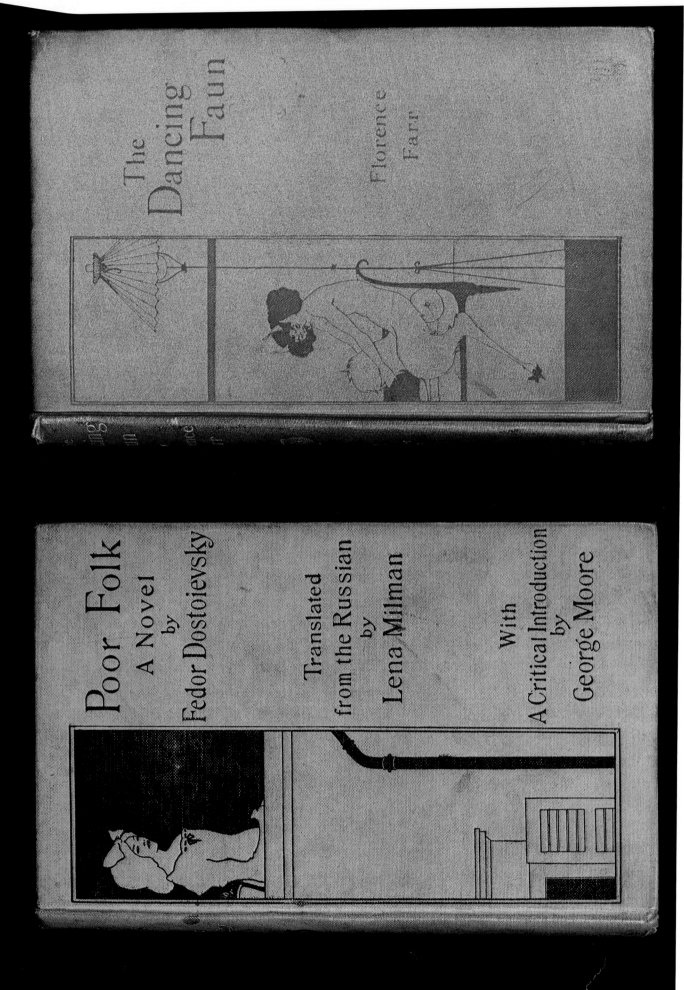

41. Covers of *Poor Folk* and *The Dancing Faun*. Both 1894. Printed cloth. London, Simon Wilson

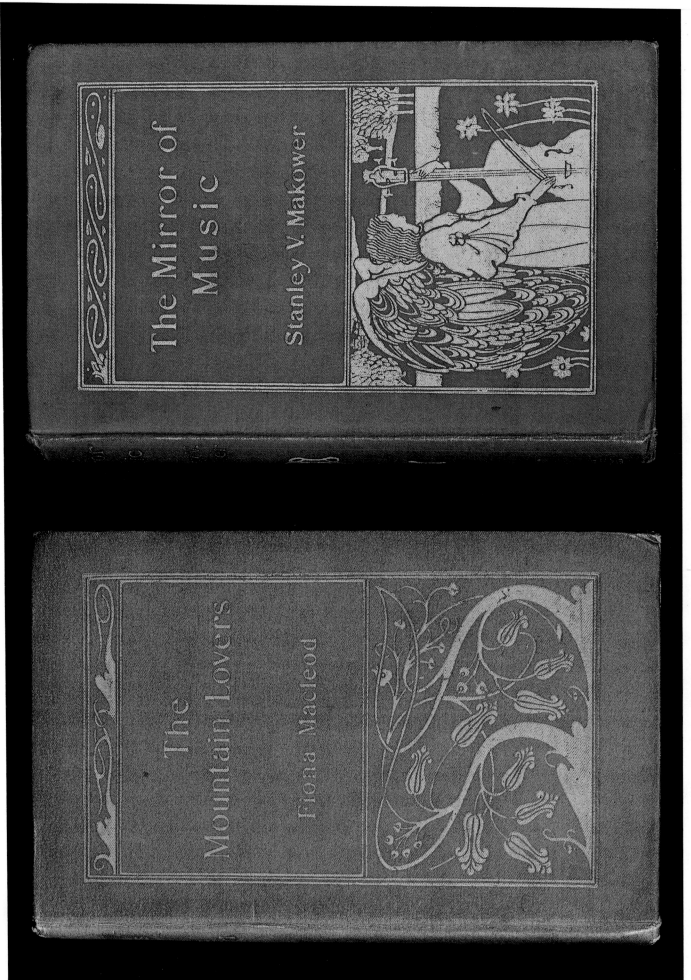

42. Covers of *The Mirror of Music* and *The Mountain Lovers*. Both 1895. Printed cloth. London, Simon Wilson

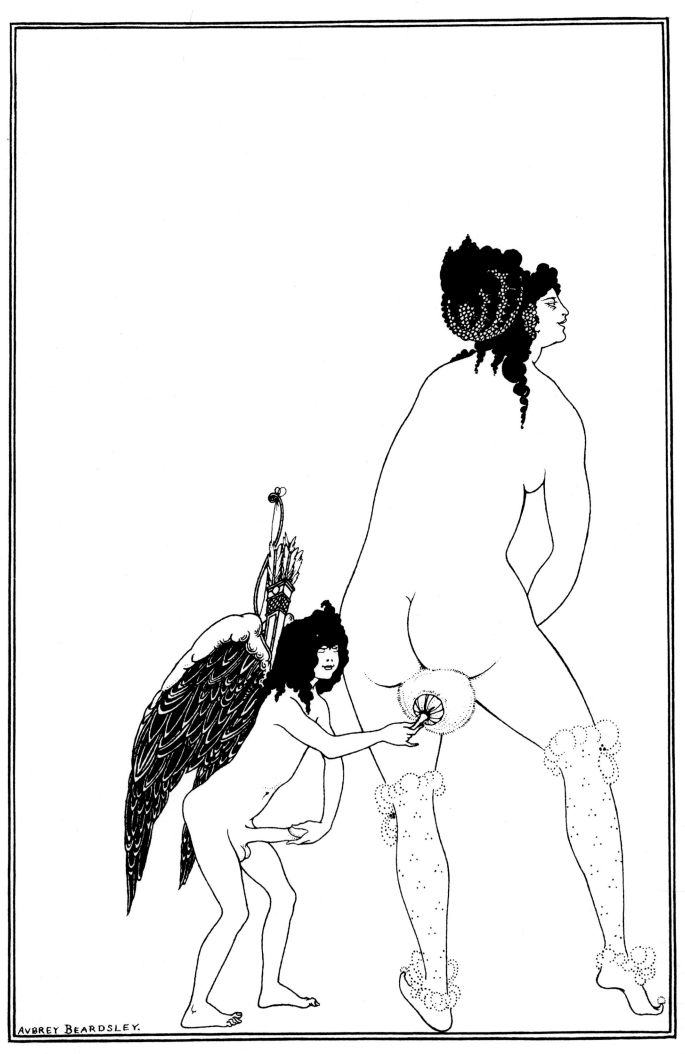

43. *The Toilet of Lampito.* 1896. Pencil and ink. London, Victoria and Albert Museum

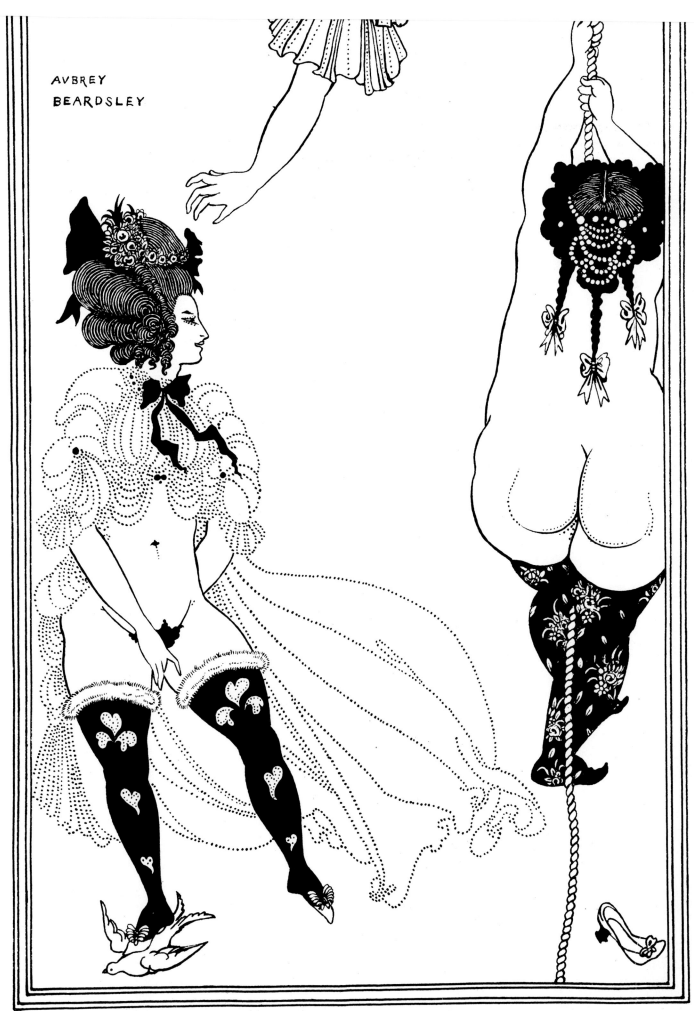

AVBREY
BEARDSLEY

44. *Two Athenian Women in Distress*. 1896. Collotype. London, Victoria and Albert Museum

46. Cover of *Verses*. 1896. Parchment board. London, Robert M. Booth

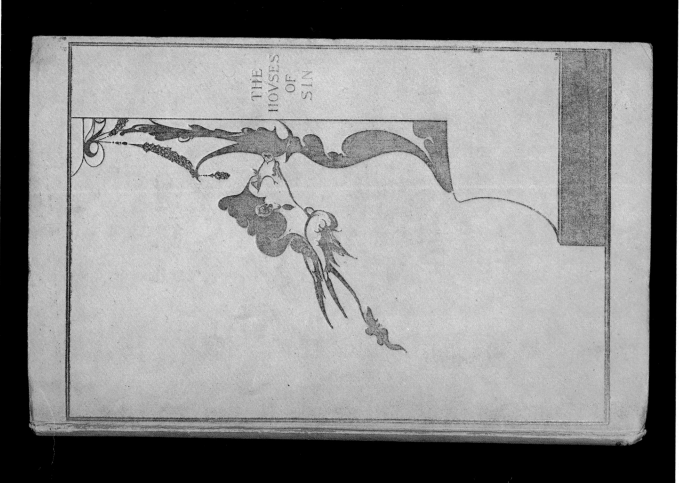

45. Cover of *The Houses of Sin*. 1897. Parchment board. London, Simon Wilson

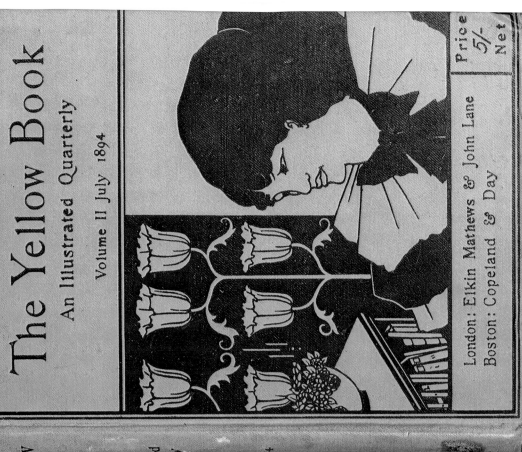

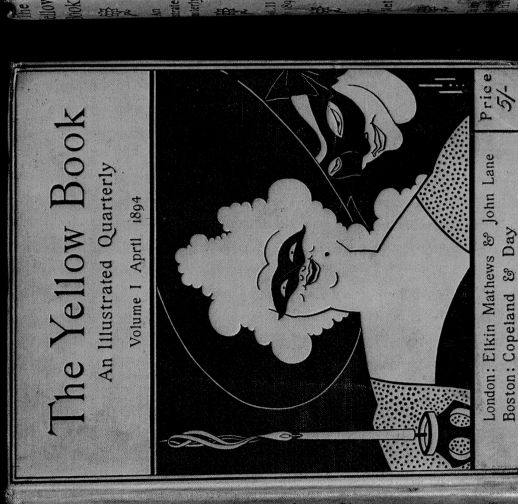

47. Cover of *The Yellow Book*, vols. I and II. 1894. Printed cloth. London, Simon Wilson

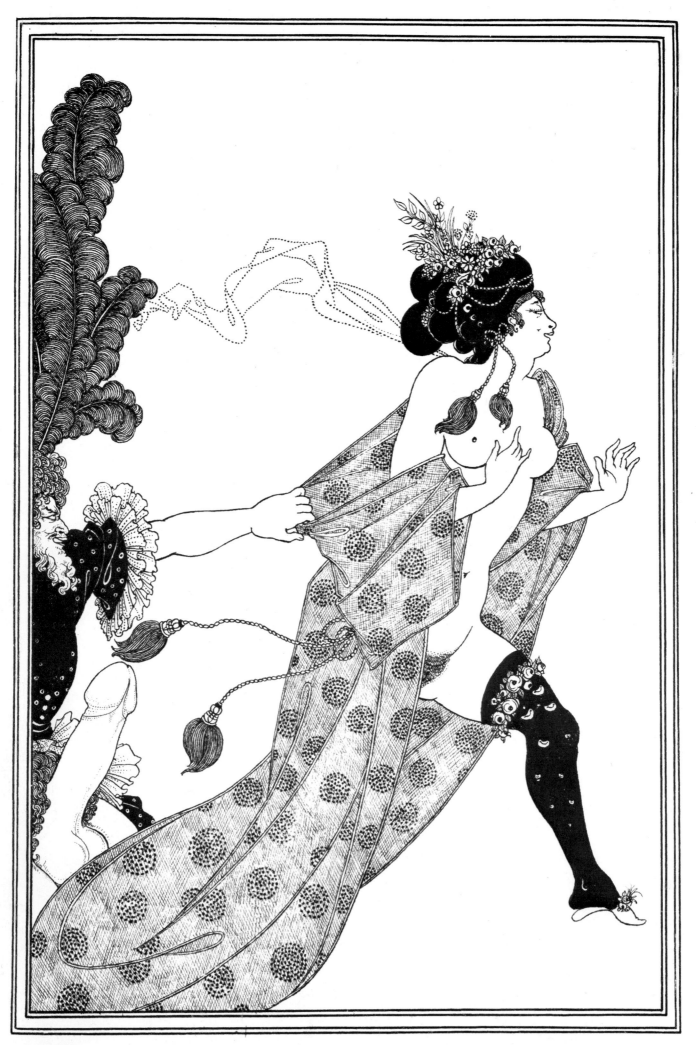

48. *Cinesias Entreating Myrrhina to Coition.* 1896. Pencil and ink. London, Victoria and Albert Museum

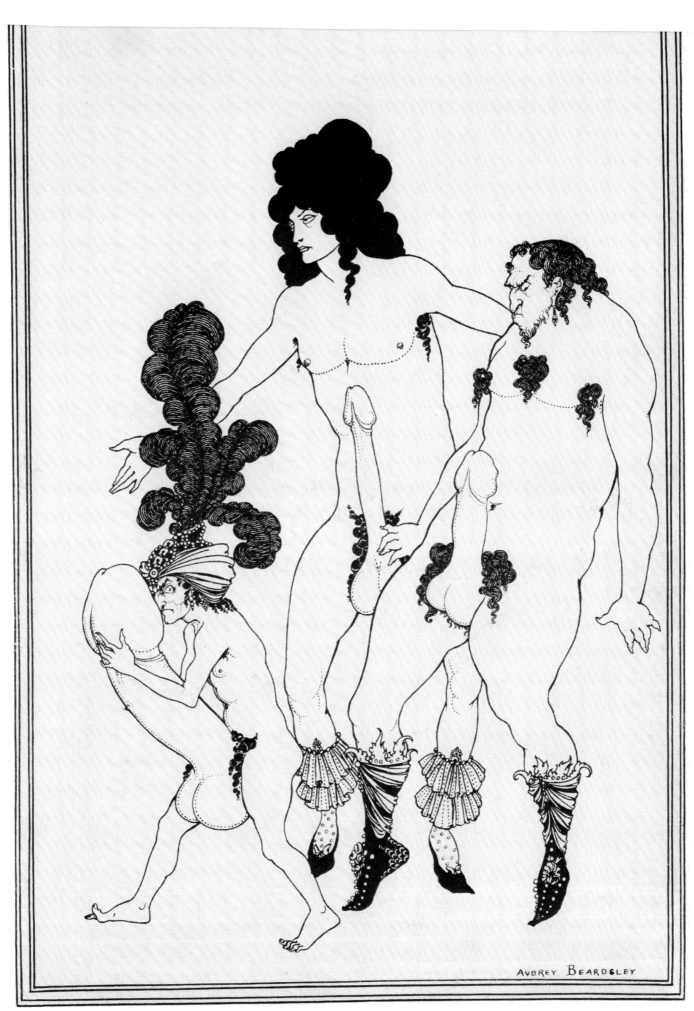

49. *The Lacedaemonian Ambassadors.* 1896. Pencil and ink. London, Victoria and Albert Museum

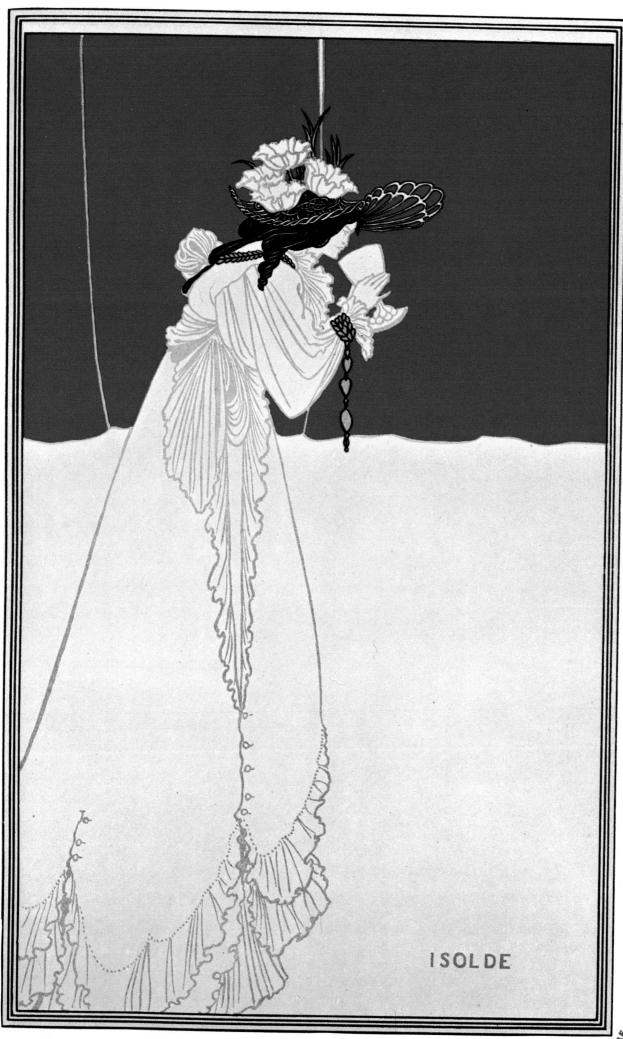

ISOLDE

50. *Isolde.* 1895. Colour lithograph